art for writing

Joan Chambers and Molly Hood

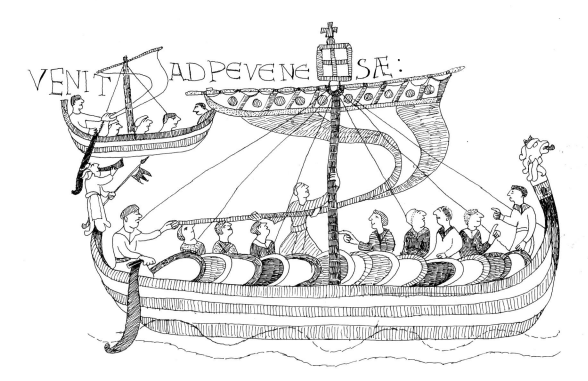

Artist's impression - part of Bayeux Tapestry, see page 55

Line drawings by Heather Hacking

Acknowledgements

The authors and publishers would like to thank the following:

- For the lovely artwork shown in this book: the children of Benedict First School, Mitcham, Surrey - and also Genaro Benmayor, Alexandra Chambers, Stephen Chambers, Alec Makarein, Amelia Makarein, Gabrielle Makarein, Scott Makarein, Ischani Wheeler, Sulfiati Wheeler, Rizal Wheeler, Charlotte Vissar and Jonathan Taylor.

- The staff and headteacher of Benedict First School, Mitcham, Surrey, for their co-operation during the preparation of the book.

- Tim Fryer for the loan of resource material.

- Stephen Chambers for the cover artwork.

They would also like to thank the Mary Rose Trust in Portsmouth for information regarding the *Mary Rose*, and for their permission to use the drawing of the ship on page 69.

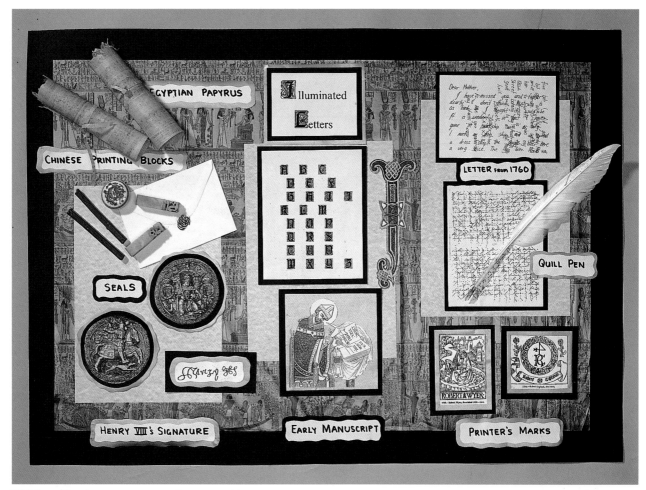

Writing display - see page 61

First published in 1997 by BELAIR PUBLICATIONS LIMITED
Albert House, Apex Business Centre, Boscombe Road, Dunstable, LU5 4RL, United Kingdom.

© 1997 Joan Chambers and Molly Hood. Series editor: Robyn Gordon Design: Lynn Hooker Photography: Kelvin Freeman
Reprinted 1998.

Printed in Singapore through Craft Print. ISBN: 0 94788 254-5

Contents

Introduction

This book presents a variety of art activities intended to stimulate children's writing. However, the art activities can be enjoyed as creative activities on their own.

• Many of the ideas can be adapted for use by children of different ages.

• The photographs illustrate a range of mounting and display techniques, and these include ways to present children's writing.

• Children enjoy novel ways of presenting writing, for example, in miniature books, on scrolls, on rolled-up paper, or spaces within patterns; on unusual backgrounds and shapes, and on objects. Inspired by art activities, children will create their own ways of presenting their writing.

• The artwork has been made using basic materials. However, we would suggest adding a small selection of metallic glitter pens and black marker pens, which are effective on most surfaces.

• Many of the art ideas can be used for a variety of topics. While covering many areas of writing, the emphasis is on creative activities and their presentation.

• All the line drawings and black and white pages at the back of this book may be photocopied for use in the classroom.

• Some historic ideas have been included to encourage interesting displays of children's work.

• The phrase 'I like writing' has been translated into several languages and can be used in wall displays or a writing corner (see pages 65 to 67 for photocopiable examples).

A way of encouraging children to write is to create a writing corner with on-going resources made by children themselves. These could include story-boxes, backgrounds for writing, prepared mini-books, cut-out shapes and folded papers. Add some manufactured sticky labels, notelets, paper clips, stapler, and a variety of writing implements. The corner could include a variety of texts, lettering and computer fonts to copy. (See pages 63 and 64 for some photocopiable examples.)

We hope you find that the ideas in this book will encourage children to enjoy writing and to present their written work creatively.

Joan Chambers and Molly Hood

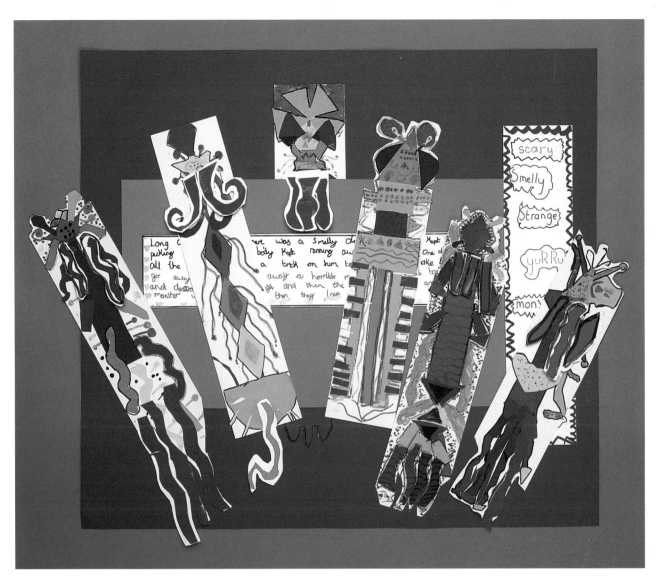

MONSTER BOOKMARKS

Materials

Large rectangles of card, plus scraps of card Felt-tip pens
Coloured paper Scissors and glue

1. Using coloured paper, cut out a body shape, for example, triangle, rectangle, oval.
2. Cut out unusual head shapes (one or more). Glue each head and body on to the card.
3. Add legs, arms and details. Cut in an unusual way, for example, in curves, scallops, zigzags, etc.
4. Add extra pairs of arms using scraps of card covered with coloured paper. Glue one end only so that the arms hang over a page to mark the place in the book.

• Write descriptive words about monsters on the back of the bookmark to make an individual word bank.

• Write a 'monster' story on the back of the bookmark.

• Think of a theme for the monsters, for example, space or sea monsters. Make the bookmarks using appropriate colours for the theme. Write a story about the monster and make it into a matching book.

• Make very large bookmarks to use in giant books for younger children. These could be in the shape of characters from the book.

BOOK COVERS

Materials

Thin card or stiff paper
A dust cover from a hardback book - to
 use as a template
Materials to decorate covers - for
 example, felt-tip pens and glitter

1. Open out the book cover and use as a
 template. Draw around it on the card
 or paper and cut it out. Fold it like the
 original.
2. Decorate the front cover, spine and
 back cover. Add writing on the flaps:
 for example, a synopsis and critics'
 reviews.

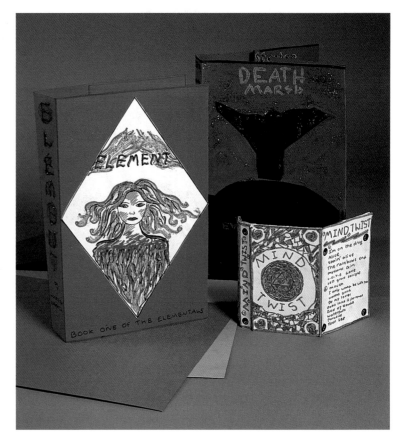

DESIGNER STATIONERY

Materials

Paper in a variety of colours
Card
Materials to use for decoration, for example,
 rubber stamps, metallic pens, felt-tip pens, wrapping paper
Ruler, pencil
Scissors and glue

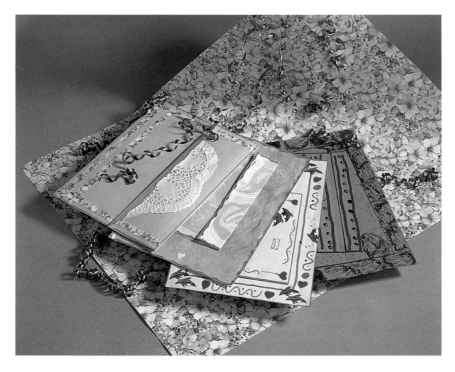

1. Take two sheets of paper of
 the same colour and rule a
 line around one of them to
 make a border for the
 notepaper.
2. Create a regular pattern
 around the border using
 rubber stamps, and complete
 using the materials above.
3. Using the other sheet of
 paper, design an envelope.
 Decorate it to match the
 notepaper.

• Using scraps of paper, find
 different ways of making an
 envelope.
• Make a folder for the
 stationery. Use the notepaper
 for thank you letters,
 invitations, etc.

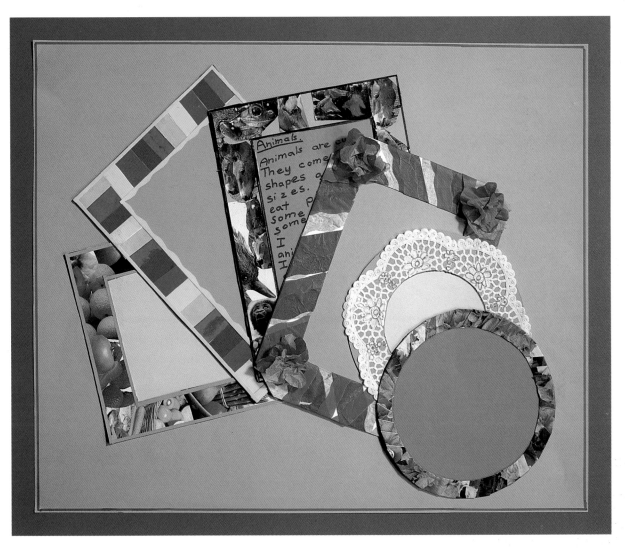

FRAMES

All the frames are made from thin card. For the oblong frames, rule a border around the edge the width of a ruler. Cut out the inner shape.

• Animal/fruit frames

Cut out appropriate pictures from magazines, and glue these on to the frame. Cover the frame completely, folding some of the pictures on to the back. Glue thin strips of card along the inner and outer edges of the frame to give a neat finish. (See the three frames on the left of the photograph.)

• Striped frames

Cut some thin strips of brightly coloured paper slightly wider than the frame. Spread glue on the frame and overlap the strips all the way round. Fold the ends over and glue to the back of the frame. Complete with thin strips as above.

• Tissue paper frames

Cut wavy strips of tissue paper. Glue one end of a strip on to the frame and wind around the frame, leaving spaces. Fasten with glue. Repeat with the other colours. Decorate with tissue paper flowers.

• Doily frames

Cut out a wide ring shape from coloured card which is slightly smaller than a doily. Spread glue on the ring and place the doily on it. Push scissors through the middle of the doily and cut the centre into sections. Glue the doily on to the back of the ring.

• Flower frames

Cut out large flower-covered pictures (for example, from a seed catalogue). Cut into thin strips. Glue the end of a strip to the frame and wind it around. Repeat with other strips.

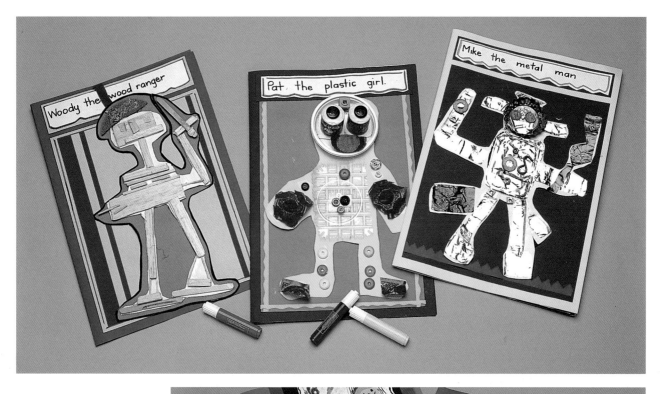

GIANT BOOKS

Materials
for the 'wooden' book

A variety of scrap
materials in wood,
for example, lollipop
sticks, used matches,
sawdust, etc.
Large pieces of coloured
card for pages
White or coloured paper
for labels and writing
Felt-tip pens
Scissors and glue

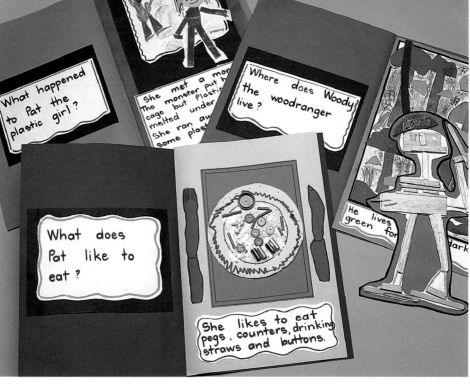

1. Arrange the wooden materials first to make a figure. Glue this on to a piece of paper and cut out.
2. Invent a name for the character. This becomes the title of the book.
3. Write one question per page. For example, Where does he live? What does he like to eat? On the page facing each question, make a collage picture and write a sentence underneath.
4. Attach the character with ribbon to the top of the book and move it from one page to the next.

• Make other book cover characters from plastic, metal, fabric.

• Make simple costumes or hats and act out stories involving these characters.

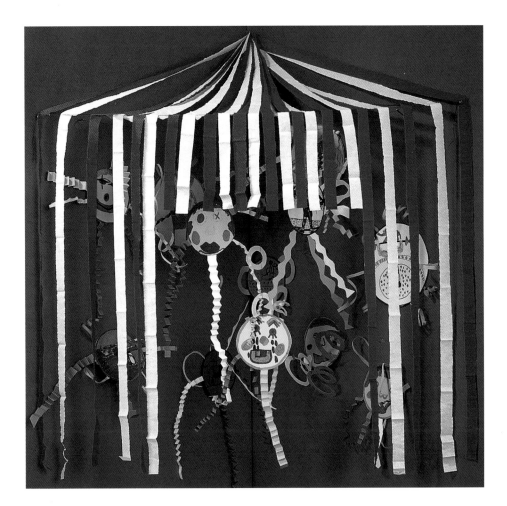

CIRCUS SCENE

Materials for the circus characters
Circles of cardboard in bright colours
Pieces of coloured card and paper
Felt-tip pens, scissors and glue

Materials for the circus tent
Strips of red and white crêpe paper
Pieces of string or cotton to pin across the
 corner of the room
Adhesive tape

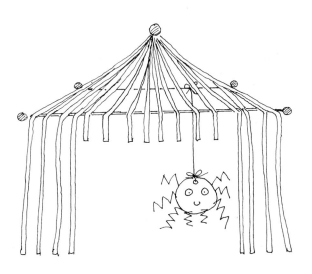

CIRCUS CHARACTERS
1. Using felt-tip pens, draw circus characters on the
 circles, for example, clowns, acrobats, trapeze artists,
 etc. Outline the edge of each circle with felt-tip pen.
2. Write about the character on the back of each circle.
3. Using the coloured card or paper, cut spirals, curls and thin strips. Fan-fold the strips and glue these
 shapes on to the circles. Add string or cotton to each one.

CIRCUS TENT
1. Cut across a roll of red crêpe paper to create strips. Repeat with white crêpe paper.
2. Hold the strips together at one end, alternating red and white. Secure with adhesive tape.
3. Attach two pieces of string across a corner (see line drawing) and hang some circles from the inner string.
 Attach other circles to the walls.
4. Pin the red and white strips into the corner. Drape the strips across the front string to form the tent. Trim
 off the middle strips to form the opening into the tent.

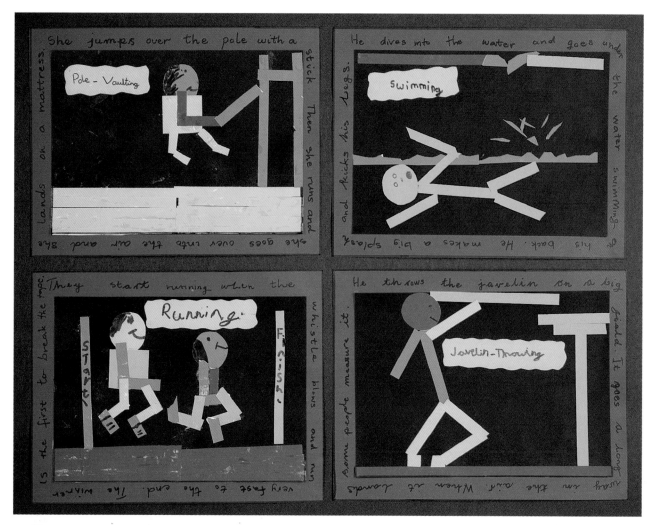

ATHLETES

Materials

Black paper for background
Larger piece of coloured card for mount
Strips and circles of brightly coloured paper

Sheet of paper and pencil
Felt-tip pens
Scissors and glue

1. Experiment by drawing stick figures showing a variety of movements which are involved in running, jumping, diving, swimming, etc.
2. Choose a figure and make it using a circle and strips. Glue on to the background.
3. Add details using felt-tip pens. Write labels to show which sport each figure represents.
4. Glue on to the mount and write around the edge.

• Talk about the sports played in the Olympic games. Make a group collage of sporting figures (cut from magazines and newspapers).

• Play slow-motion guessing games about sports.

• Make large figures in card, and use split pins so that the joints can be moved to show different actions.

• On a large sheet of paper, glue down a group of figures, for example,
 runners in a race
 footballers on the field

 skiers on a slope
 dancers on a stage.

• Make flick books with figures moving, for example, throwing a javelin or jumping over a bar.

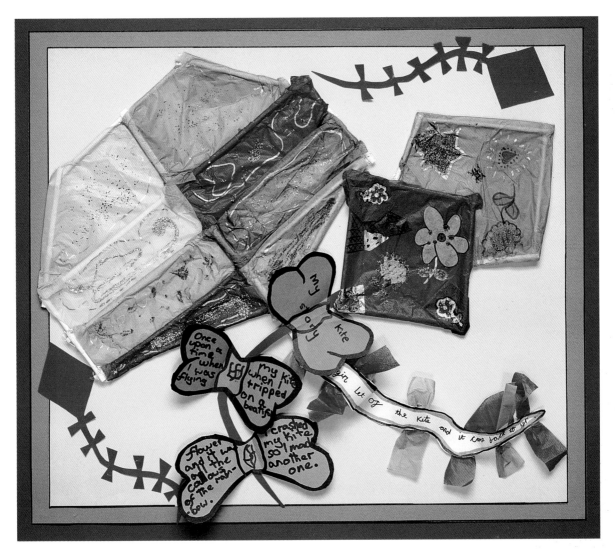

KITES

Materials

Tissue paper in bright colours
Art straws
Scraps of coloured paper and shiny scraps

Pens for decorating kites
Adhesive tape
Scissors and glue

1. Take some art straws and move them around until you create an interesting kite shape.
2. Join the straws together with adhesive tape to form the kite.
3. Place the tissue paper underneath the straw shape. (The tissue paper should be slightly larger than the kite.)
4. Fold the surplus tissue over the straw and glue it down. Continue with different colours until the whole kite is covered.
5. Decorate the kite using paper, pens and scraps.

• Find different ways of making a tail, and write a story on it.

• Write a story on the kite with silver or gold pen.

• Make other objects with straws and tissue paper, for example, butterflies, fish.

• Hang the kites from the ceiling and make long tails which loop across the ceiling and hang down. Write stories on card and hang them as mobiles in between the kites.

• Suspend some of the kites in front of a window to allow the sun to shine through them. Write stories on paper cut into kite shapes and hang these in between the kites.

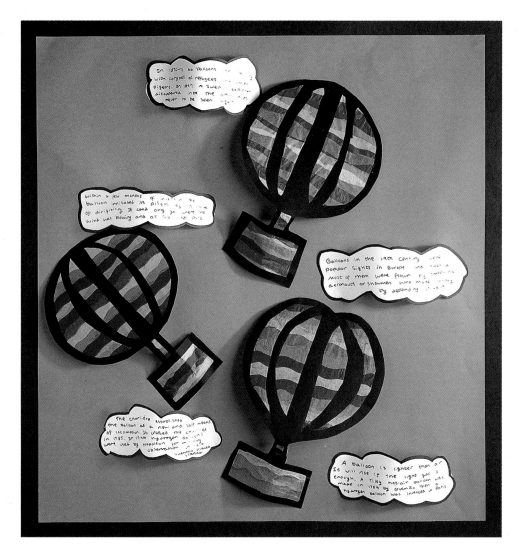

HOT AIR BALLOONS

Materials
Stiff paper in black
Piece of white paper for template
Layers of tissue paper in various colours, held together and cut into wavy strips
Extra layer of tissue paper
Pencil and chalk
Scissors and glue

1. To make the template, fold the white paper in half lengthways.
2. Starting at the fold, draw half a hot air balloon and shapes inside this as shown in the line drawing.
3. Keep the paper folded and cut out the balloon and the shapes.
4. Open the template out and place on the black paper.
5. Using chalk, draw around the template and the inner shapes. Cut out.
6. Starting at the top, spread glue over half the balloon. Overlap the strips of tissue paper across the balloon.
7. Repeat for the lower half. Glue the extra layer of tissue paper on the back.
8. When dry, trim round the edge.

• Add writing on the cloud shapes.

• Make balloons using coloured paper instead of tissue paper **(as shown on the cover of this book)**.

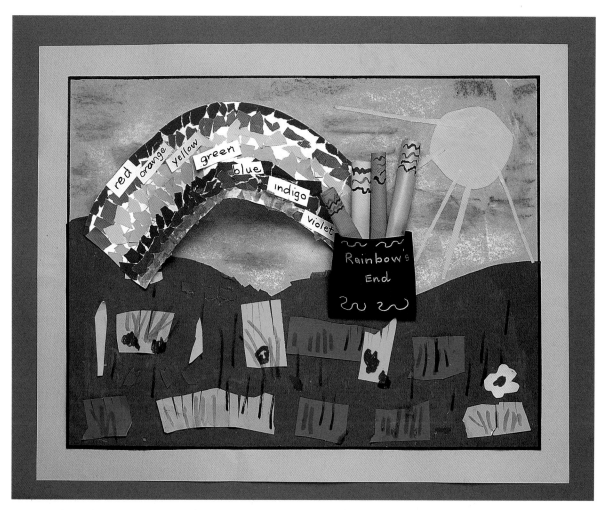

RAINBOW PICTURE

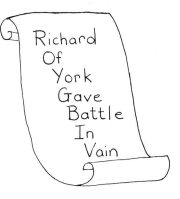

Materials

Piece of grey paper for background
Piece of white paper cut into a rainbow shape
Green paper cut in a wavy shape for hills
Small pieces of fringed paper in a variety of greens for the grass
Scraps of coloured paper for rainbow and sun
Piece of black paper for pot
Chalks for sky - in pink, yellow and mauve
Pencil
Scissors and glue

1. Glue hill on to background and add grass pieces.
2. Using the side of each chalk, colour the sky.
3. Draw seven lines along the rainbow following the shape. Starting at the top, glue small pieces of torn coloured paper along the line. Repeat with other colours and add labels.
4. Glue sun and rainbow on to the background, making the rainbow stand out.
5. Make a pot from the black paper and glue to one end of the rainbow.
6. Write about what could be found at the end of the rainbow. Roll up the paper and place in the pot at the end of the rainbow.

• Find out how to write the colours in other languages on the rainbow.

• The idea can be adapted for a colour topic.

• **Learn the sentence "Richard of York gave battle in vain"** in order to remember the order of the colours of the rainbow: *red, orange, yellow, green, blue, indigo, violet.*

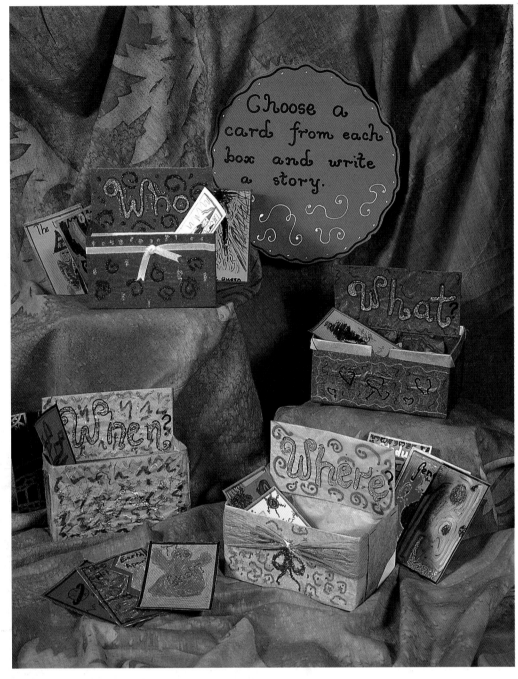

STORY BOXES

Materials

4 small cardboard boxes (for example, tea bag boxes)
Tissue paper in various colours
Shiny scraps
Glitter pen (or glitter and glue)

Small pieces of card
Marker pen
Felt-tip pens
Scissors and glue

1. Cut off the flaps and lid from each small box. Spread glue on the inside of each box and cover with tissue paper. Repeat on the outside of the box. Leave to dry.
2. Cover each lid with tissue paper and re-attach it by gluing it to the back of the box. Write one of the 'question' words *(who, when, where, what)* on each of the lids with glitter pen or felt-tip pen.
3. Decorate the outside of the boxes with shiny scraps and pens.
4. Make a set of small cards for each question box. For example, for the *Who?* box, draw a character on each card and decorate with felt-tip pens.

• Choose a card from each box and use these four cards as a basis for a story.

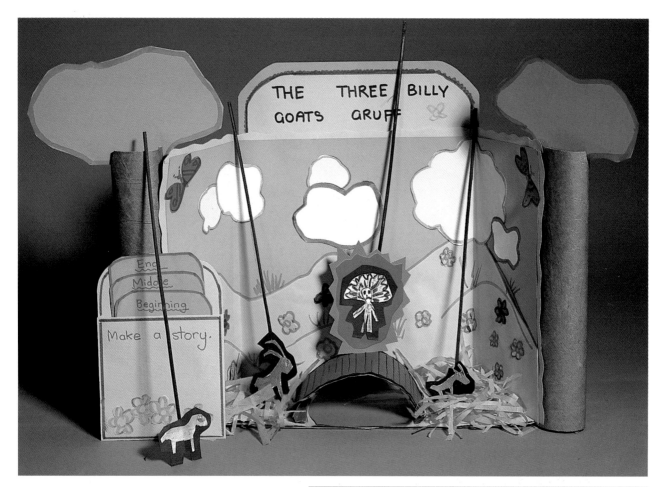

BILLY GOATS GRUFF - STORY THEATRE

Materials
Blue card
Green paper
Small pieces of card and coloured paper
Green tissue - shredded finely for the grass
Brown and green paper for trees
Thin sticks or straws for the puppets
Paper clips
Felt-tip pens, scissors and glue

1. Fold the blue card to make two equal flaps that meet in the middle. Cut and shape the top edge if desired.
2. Open out and fold up the bottom third and cut two slits as shown. This forms the base. Use paper clips (or glue) to attach the bottom sections to each other and to adjust the angle of the side flaps.
3. Cut hills, clouds and flowers from coloured paper and decorate the background. Place a piece of blue card on the base to make a river. Make a bridge and stand it over the river. Add shredded green tissue for grass.
4. To make trees, roll up brown paper for the trunks and cut out tree tops from green card. Make two slits in the trunks to hold the tops. Attach to the flaps with tape.
5. Make the puppets from pieces of card and attach sticks to the back.
6. Using card, make a pocket to hold three pieces of card marked 'Beginning', 'Middle' and 'The End', on which to write the story of the Billy Goats Gruff.

• A group could create their own writing and puppets based on other stories and topics.

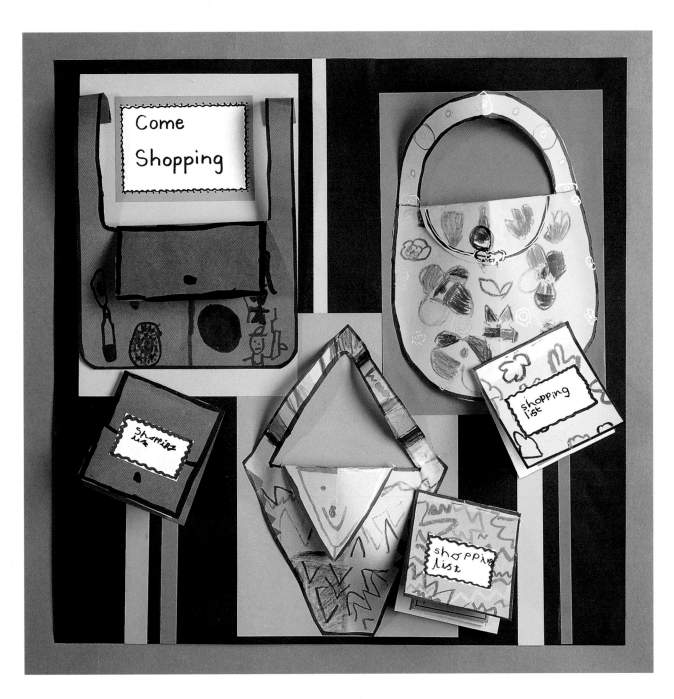

SHOPPING BAGS

Materials

Pieces of coloured card
Oil pastels
Felt-tip pens

Small pieces of paper for shopping lists
Scissors and glue

1. Fold a piece of card in half and, starting at the fold, draw half a bag shape with a handle.
2. Starting at the fold, cut out the bag shape. Cut around the inside of the handle and keep this shape to make the flap.
3. Open the shapes out and decorate with the pastels. Attach the decorated flap to the bag.
4. Cut and fold a small piece of card to make the notebook cover, and decorate this. Glue or staple small pages into the notebook.
5. Use the notebook to make shopping lists with headings, for example, *fruit and vegetables, sweet things, drinks, small toys, presents.*

• Use this idea to make a Mother's Day or Christmas card, writing the message on the flap.

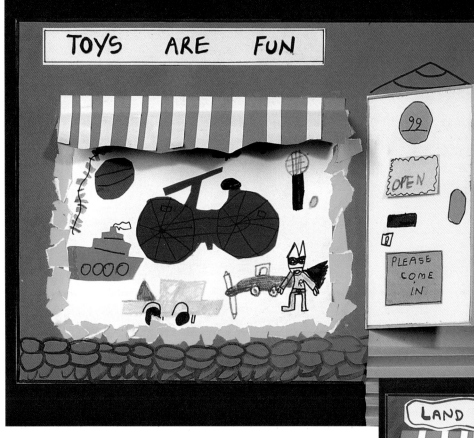

TOY SHOPS

Materials
Coloured paper for the background
Piece of coloured card and white strips of paper for awning
White paper for window
Piece of paper or coloured card for door and steps
Pieces of coloured paper for toys and window frame
Felt-tip pens and crayons
Scissors and glue

1. Glue white paper on to the background.
2. Draw and cut out a favourite toy from coloured paper. Decorate with felt-tip pens. Glue this down. Draw other toys using felt-tip pens and crayons.
3. Glue white strips on to the awning and attach to the picture.
4. Tear pieces of coloured paper into small pieces and glue around the window to make a frame.
5. Fold a piece of card or paper in half to make the door and glue this down.
6. Glue on fan-folded steps.
7. Write about favourite toys, or the toy shop, on the back of the door.
8. Invent a name for the toy shop and glue a sign above the window. Try different scripts.

• Make other toy shop windows to specialise in the following:

miniature toys	bedtime toys
playground toys	old-fashioned toys
baby toys	bathtime toys

• Make a Victorian window with a bow-front and decorate with Victorian toys.

17

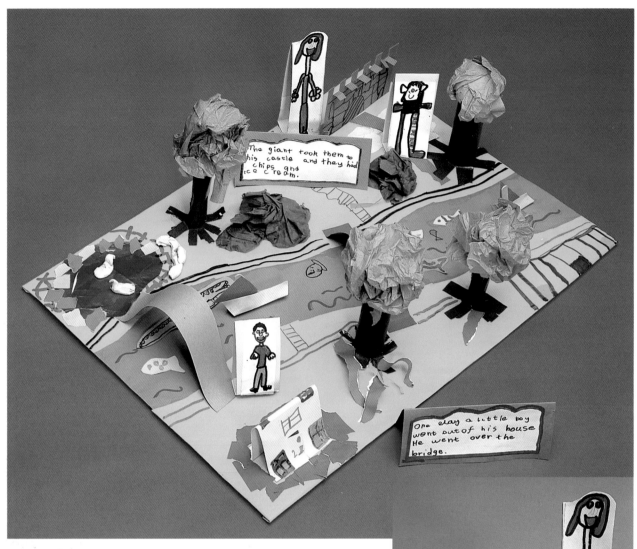

The giant took them to his castle and they had chips and ice cream.

One day a little boy went out of his house He went over the bridge.

STORY MAP

Materials
Large sheet of paper or card for base
Green paper, larger than base
Blue paper for river
Coloured papers and tissue paper for houses, bridges, castle, etc.
Scraps of card for figures
Felt-tip pen
Scissors and glue

1. Cut a wavy line across the large piece of green paper and separate the two pieces with the blue paper underneath to form the river. Glue on to the base.
2. Start at one corner of the picture and make a building from card. Then put another building in a different corner. Add other objects, for example, trees, bushes, bridges, etc., that might be seen in the countryside or park.
3. Draw and cut out two or three main characters and glue them on to card to make them stand up.

• Decide where the story begins. Write a sentence about it on a piece of folded card and place it on the story. Repeat for the middle and the end of the story.

• Use this for historical themes, for example, to tell the story of a battle or journey, or stories from other cultures.

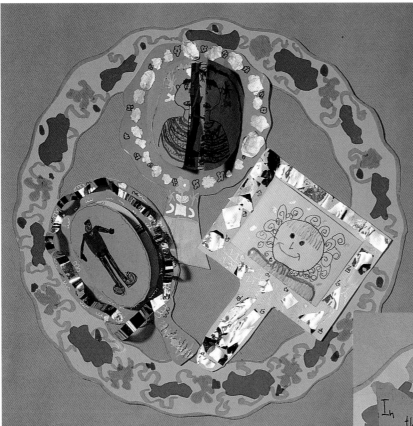

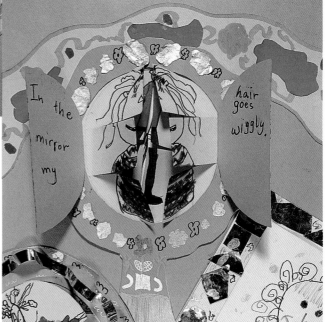

THROUGH THE MIRROR

Materials
3 pieces of card of the same size, in different colours
Scraps of shiny paper
Metallic pens
Felt-tip pens
Scissors and glue

1. Fold one piece of card in half. Draw half a mirror shape, starting at the fold, and cut it out.
2. Use this shape as a template to make two more mirror shapes.
3. Keep one mirror shape for the back. Make two different openings in the other shapes.

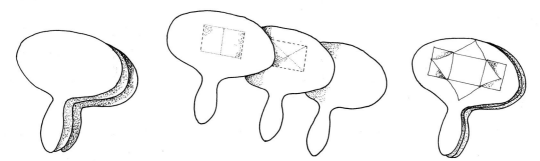

4. Glue the three mirrors together around the edge. On the first mirror shape, draw yourself; on the second, draw how you are changing; and, on the last, draw what you have become.
5. Write about each of these on the undersides of the flaps.

• A simpler version can be made with one flap only.
• Instead of hand mirrors, make a large wall-mirror with an ornate frame.

EASY BOOKS

1. Fold a sheet of paper in half and half again to form eight rectangles. Make a mark as shown.
2. Re-fold paper in half widthways and cut from the fold to the mark.
3. Re-fold in half lengthways and form a book as shown.
4. Cut small flaps if desired from some of the pages.

• Make a book with a larger sheet of paper so that the individual pages are bigger.

• Write stories in languages other than English.

• The books can be joined together to make a longer book.

• They can be used for a variety of topics based on science, maths, etc., or for giving instructions, for example, a recipe.

• Make miniature history books, telling the story of a character, for example, Henry VIII, Guy Fawkes, Queen Victoria. The story could be told in cartoon form using speech balloons. Hang these next to a portrait of the person.

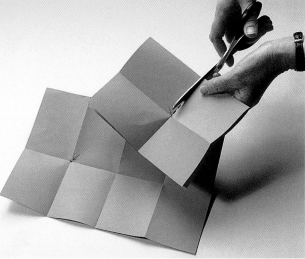

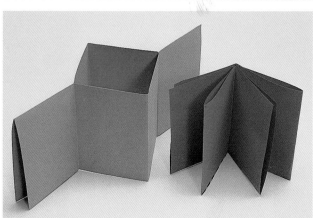

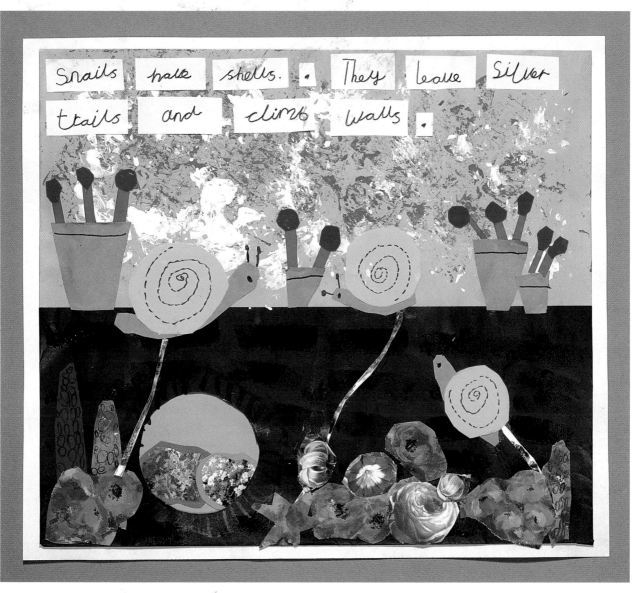

Snails have shells. They leave silver trails and climb walls.

GARDEN WALL

Materials

Paper for background
Blue paper for sky (larger than background paper)
Brown or beige paper for wall
Brightly coloured paper for snail shapes, pots and
 the view through the wall
White paint and black paint

Wrapping paper
Silver paper or pen (for trails)
Crumpled newspaper, small sponge
Felt-tip pens
Scissors and glue

1. Cut out a circle from the brown paper to create a hole in the wall, and attach a piece of coloured paper behind the hole.
2. Glue the sky and the wall on to the background, and glue surplus edges at the back.
3. Print sky with crumpled newspaper and white paint. Print wall with sponge and black paint.
4. Draw and cut out snail shapes and glue on to the wall. Add silver trails.
5. Cut out flowers from wrapping paper and glue on to the wall. Add flower pots or other garden objects.
6. Draw or glue on pictures to create the view seen through the hole in the wall.

• Write sentences on adhesive labels and attach these to the sky.

• Make a brick pattern on the wall and write one word on each brick to make a sentence.

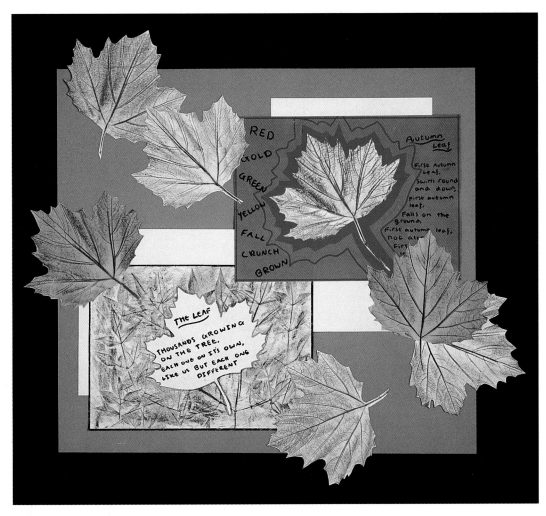

AUTUMN LEAVES

Materials
Pieces of coloured paper, for background and leaves
Piece of white paper for leaves
Crayons in autumn colours and shades of green

One autumn leaf and one stem of leaves
Felt-tip pens
Scissors and glue

Orange picture
1. Place a leaf under a piece of white paper (vein side up). Holding it in place, rub firmly using the sides of crayons in autumn colours. This gives the leaf a multi-coloured effect.
2. Cut around the leaf rubbing. Glue it on to a piece of coloured paper and cut around the leaf shape. Glue this on to a background.
3. Write autumn words, story or poem around the leaf **(as shown in the orange picture).**

Green picture
1. Place a stem of leaves under a piece of paper.
2. Rub over the stem of leaves using crayons in various shades of green. Move the stem of leaves around and rub over it to cover the background.
3. Turn over a leaf rubbing and use the white side to write on. Glue it down on the rubbing background **(as shown in the green picture).**

• Cover a large page with leaf rubbings then cut into strips to create borders for display boards.

• Paint a large simple tree shape. Write autumn words or phrases on rubbed leaf shapes and glue these on to the tree to make a wall display.

• Write short poems on rubbed leaves and attach them to real branches. Stand these in a pot, held with adhesive putty.

Some daffodils are here.
Play in the grass.
Red flowers coming.
I see plants growing.
No more snow.
Green leaves showing.

Spring is here
Pretty flowers grow.
Rabbits running around.
I see blossoms.
Now summer is coming
Girls and boys like to
play outside.

Spring is here at last.
Plants start opening up.
Roses opening their petals.
In spring baby animals are born.
Now it is spring lambs are skipping
around their mothers.
Golden daffodils opening up.

SPRING POEMS

Materials
Coloured paper for background
Tissue paper for flowers in various
 colours
Coloured paper for stems and leaves
Paper with spring poem or story written
 on it
Scissors and glue

1. Cut around the shape of the poem and glue on to the background.
2. Make the flowers using three circles of tissue. Glue each layer of tissue together in the centre and twist.
 Glue on to the picture and open out the petals.

• Try making flowers in different ways, for example: use squares; cut with pinking shears; cut zigzags, fringes
 or scallops around the edge before assembling.

• Cut out flower shapes from coloured paper. Glue them down as a background and write the poem across
 them.

• Make a large flower shape and write the poem on a circle of paper to create a centre.

• Make large 'tabletop' flowers with writing in the middle **(as shown in the smaller photograph above).**
 Each child could make a flower which then becomes part of a table display.

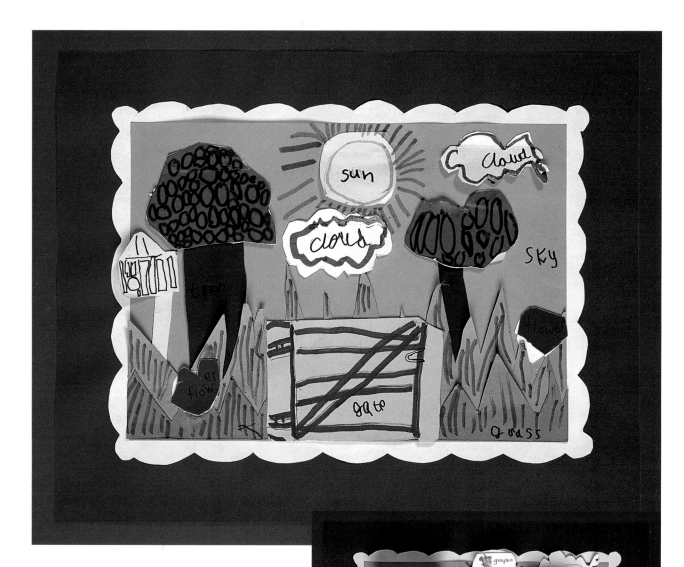

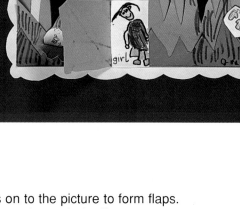

SURPRISE GARDEN

Materials
Piece of coloured card for background
Felt-tip pens
Strips of coloured card for grass
Scissors and glue
Scraps of coloured card for gate, trees, etc.

1. Cut zigzag strips for the grass.
2. Cut tree trunks and glue on to the background.
3. Glue grass on to the picture, leaving the points free.
4. Cut out clouds, sun, treetops, etc. Glue these pieces on to the picture to form flaps.
5. Draw 'g' pictures to go under all the flaps. Glue these underneath the flaps.
6. Label all the objects.
7. Find other ways to hide things in the garden.

• Use the same idea for other places, for example, park, seaside, bathroom, kitchen - with individual sounds, or with a variety of sounds.

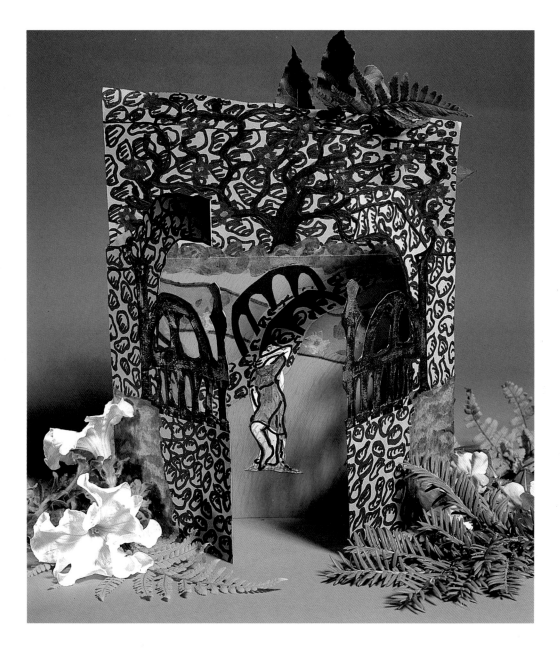

SECRET GARDEN

Materials
Piece of coloured card
Pastels or felt-tip pens
Scraps of tissue paper
Scissors and glue
Scraps of white and coloured
 paper

1. Fold the card as shown in the
 line drawing.
2. Cut the outside sections to make a shape which suggests a wall, a gate or a fence.
3. Decorate the secret garden using tissue paper and coloured paper. Include some of the following: a
 statue, a pond, a bridge, a fountain, an archway, a seat or a sundial.
4. Add a story or poem to the inside of the folded shape.

• Find out about gardens from different periods of history, for example, Roman, Medieval, Tudor. Create a
 scene for each using plants and flowers which are appropriate, for example, lavender, roses, herbs.

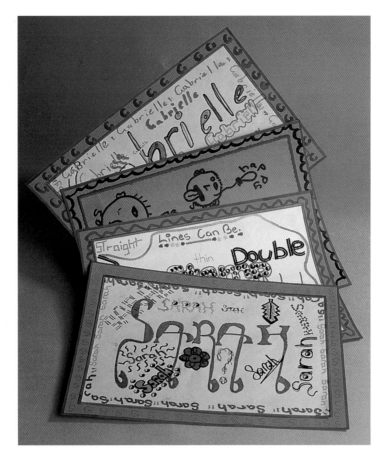

FUN WITH WORDS
Ideas for word sheets

NAMES
- Look at book titles, magazine titles, labels, advertisements, posters, etc., to see the different ways they are written. Copy some of the styles of printing and writing. (See some examples on page 64.)

- Create a border by writing your own name all around the edge of a piece of coloured paper.

- Write your name in as many different ways as possible. Use a variety of coloured pens. Add decorations if required.

- For younger children, write a name in large letters and draw around each one with various colours.

LINE PICTURES
- Write down all the words that can describe lines, for example, straight, parallel, loopy, curvy, wobbly, thick, thin, etc.

- Write these in a style to illustrate their meaning.

FEELINGS IN WORDS
- Think of some words to describe feelings, for example, *angry, happy, frightened, surprised.*

- Imagine a picture which would combine the word and the feeling. Experiment with writing words in this way. For example:

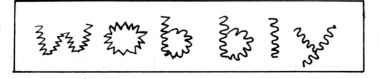 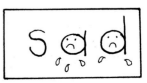

BACKGROUNDS

Make interesting and unusual backgrounds for creative writing on themes, for example, underwater, forest, etc.

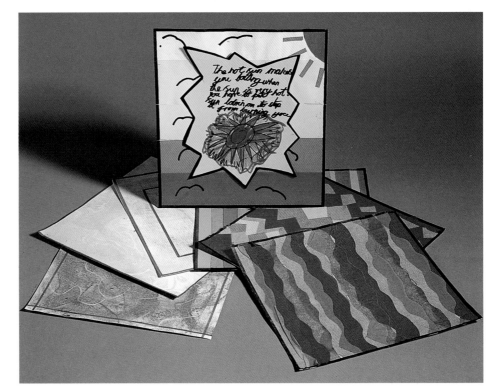

- Cut wavy strips of tissue paper for underwater or sea theme in blues and greens, and glue them in overlapping layers.
- Cut strips of coloured paper, for example, for writing about the sun - in yellow, orange and red.
- Experiment with a variety of media to create your own backgrounds, for example, pastel, paint, chalk, crayon rubbings.
- Cut around a piece of creative writing and glue it on to a suitable background.

RHYMING PICTURES

Materials
Black paper for background
Oil pastels in bright colours
Pieces of paper for writing
Pencil, felt-tip pens
Scissors and glue

1. With a pencil, write a funny rhyming sentence using two or more rhyming words. Trace over with felt-tip pen.
2. Cut a pattern round the edge and glue on to the background.
3. Illustrate the sentence using pastels.
4. Write and glue the rhyming words on to the background.

- Play games with cards. For example, around the room hide sets of rhyming words written on cards. Find the matching sets.

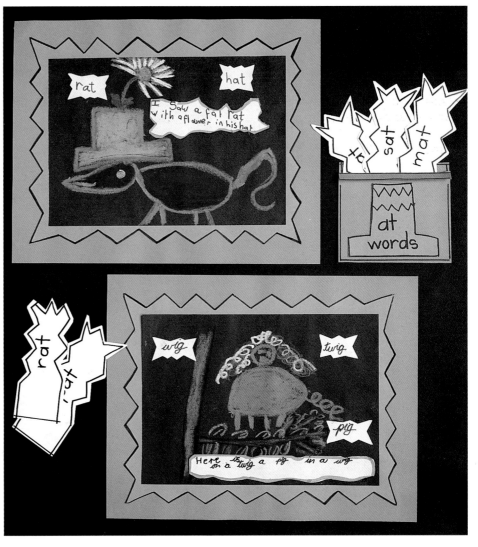

SPLIT PICTURES

Materials

Coloured paper in contrasting colours
White card and white paper
Felt-tip pens

Scraps of paper
Scissors and glue

1. Take the top piece of paper and cut it across the middle in zigzags to suggest icy shapes.
2. Separate the two pieces and glue them on to a contrasting sheet of paper. (Two of the pictures shown above were based on an Antarctic theme, the other two on the theme of heat and light. Appropriate colours were used in each case.)
3. Make into a picture using felt-tip pens, and write a story to go in the space between the two edges.
4. Mount on a piece of thin white card or stiff paper. Cut sharp points around the edge and stand these up.

• This technique can be used for a variety of themes. Experiment with other ways of splitting shapes and writing in the spaces.

• Made on a larger scale, this could become an effective wall display. Add layers of different colours.

• Draw and cut three or four wavy lines to create a watery effect. Glue these wavy strips on to a background, leaving a space in between each strip. Try blue on green, white on blue, green on blue, for different effects.

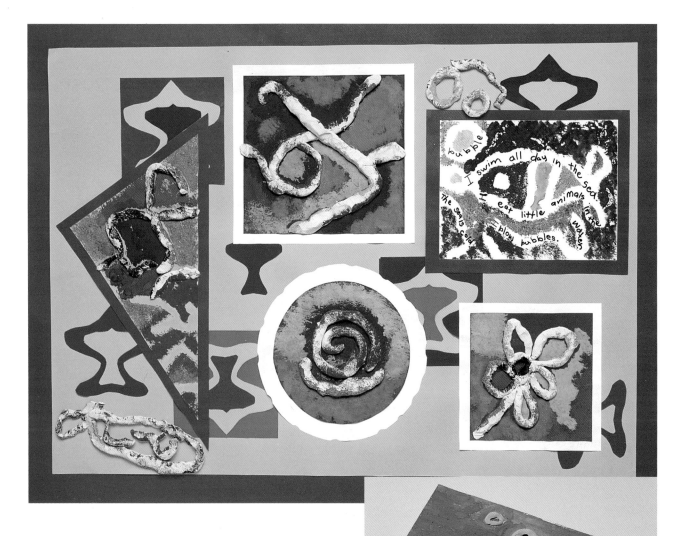

PLASTICINE PAINTING

Materials

White or pale-coloured thin card for background
Soft modelling material (for example, Plasticine)
Paints in primary colours (medium thick)
Brushes, felt-tip pen

1. Roll modelling material into long shapes.
2. Press these on to the background card to make a picture (**see small photograph above**) or an abstract pattern.
3. Using a separate brush for each colour, dab the paint close to the edges of the modelling material. Keep the brush upright and use the paint sparingly to give a dappled effect.
4. When the paint is dry, remove the modelling material and write in the spaces. (Some of the modelling material could be glued in place, if desired, and left as part of the finished picture.)

• Older children can make intricate designs using very thin strips of Plasticine.

• Use traditional patterns from various cultures.

• Make basic shapes with the Plasticine, for example, square, circle, triangle. Write about the shapes in the spaces which are created when the Plasticine is removed.

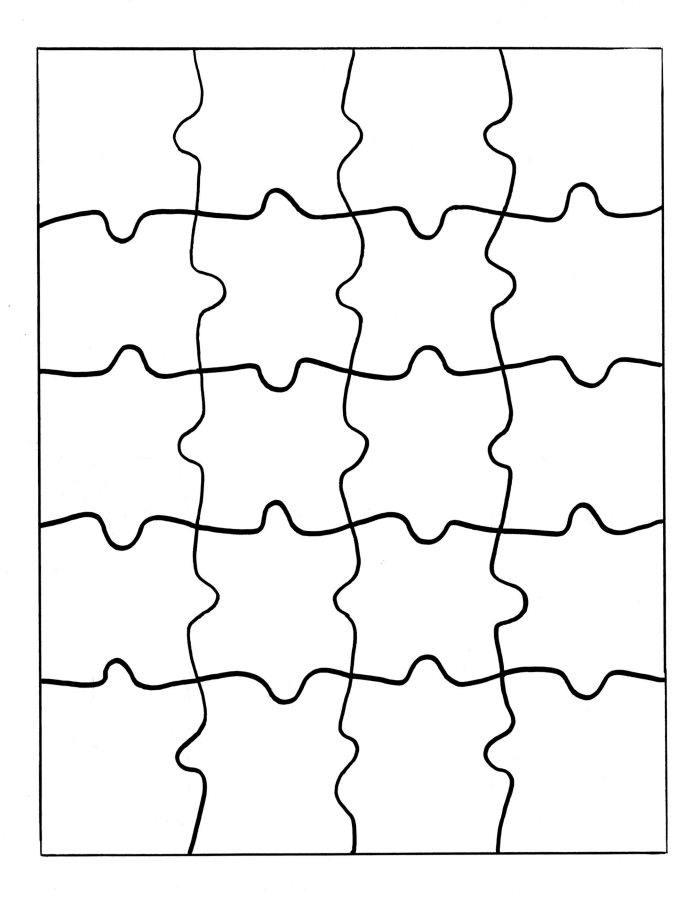

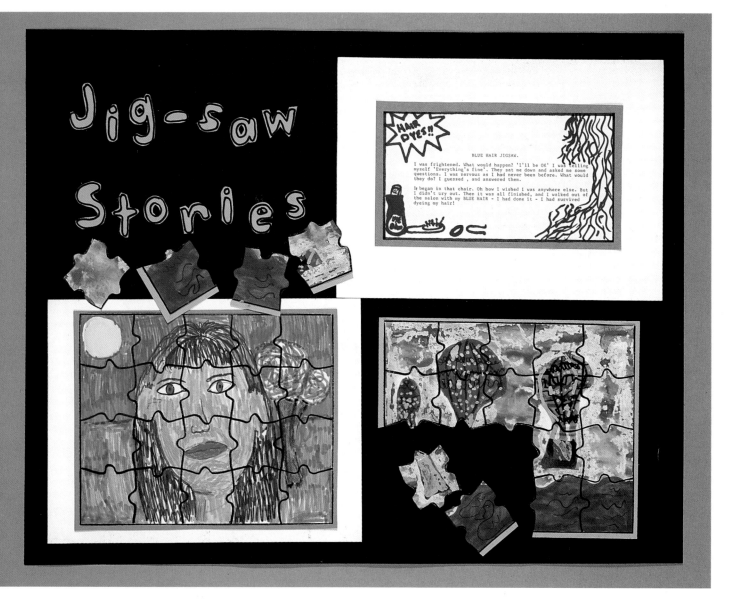

JIGSAW PICTURE

Materials
Photocopy the jigsaw pattern opposite (enlarge if desired)
Piece of card larger than the jigsaw pattern
Felt-tip pens
Scissors and glue

1. Decide on a theme for the story and picture.
2. Using the photocopied jigsaw pattern, draw and colour a picture to cover the whole sheet. Experiment with other media, for example, crayon and paint wash, gold pens, etc.
3. Cut up the jigsaw picture and put it into a box, decorated to match the jigsaw.
4. Give the jigsaw to a partner to assemble and to write about.

• Write a story and draw a picture on the jigsaw outline. Cut it up and ask a partner to put it together.

• Using a timer, swap story jigsaws with a friend and see who can assemble it first.

• For older children, reduce the jigsaw pattern on a photocopier. Find a picture approximately the same size in a magazine or brochure. Glue it on to card. Place the jigsaw photocopy over it (secured if necessary with paperclips or adhesive putty) and cut the two out together. Assemble the jigsaw and use this for story-writing.

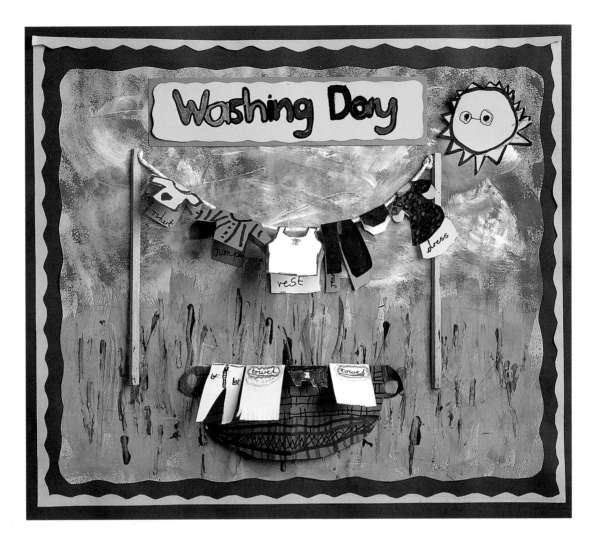

WASHING DAY PICTURE

Materials
Large piece of white paper for background
Thin card for clothes and washing basket
String or wool for the clothesline
Wooden sticks or art straws to make clothesline posts
Paint in blue, white, green and yellow
Sponge roller, ruler
Felt-tip pens
Scissors and glue

1. Using the roller, paint the sky blue. When dry, add white paint, using a swirling movement.
2. Paint the grass with a roller and green paint, using a vertical movement.
 Add yellow paint with the edge of a ruler.
3. Glue the posts in place and add the clothesline in between, attached only at each end.
4. Fold a piece of card in half. Starting at the fold, draw a garment. Keep the paper folded and cut it out.
 Repeat with other garments.
5. Decorate and label the clothes. Hang them over the clothesline.
6. Make a basket. **(See line drawing for a simple way of drawing a basket weave pattern.)**
7. Cut towels from folded card and write about 'my favourite clothes', 'washing instructions', or 'clothes for special occasions', on the larger surface that these provide.

• Make different sets of clothes for holidays (seasonal), nightwear, clothes from other countries, sports clothes.
• The picture can be made individually, in pairs or in a group.

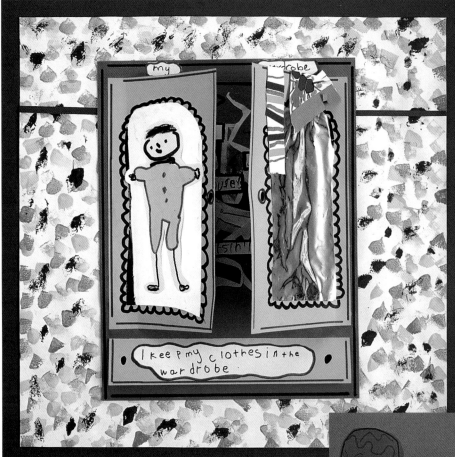

WARDROBE

Materials
Sheet of coloured card for wardrobe shape
Coloured card for doors and drawer
Larger sheet of wallpaper - optional
White paper for clothes, figure and writing
Silver paper cut into mirror shapes
Pastels
Scissors and glue

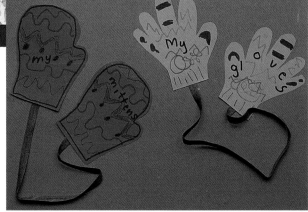

1. Glue the two doors on to the coloured card and add the silver paper mirrors. Add the drawer.
2. Draw and decorate the clothes with pastels. Cut these out and glue inside the wardrobe.
3. Draw a figure. Cut out and glue on to the mirror.
4. Display the wardrobe on a wallpaper background, if desired.

• Use magazine or catalogue clothes instead of drawn clothes.

• Draw a picture of a wardrobe at home and copy your own clothes.

• Make a wardrobe from a cardboard box. Cut the front of the box so that the doors open and close. Paint and decorate the wardrobe. Hang some clothes made from tissue or crêpe paper inside. Write out lists of the clothes you would like to have and display them with it.

• Use the wardrobes for seasonal clothing, clothes from other countries, or clothes for a special occasion, for example, summer holiday, fancy dress.

• Make mittens or gloves from card and attach each pair with thread to hang over a wardrobe door. **(See smaller photograph above.)**

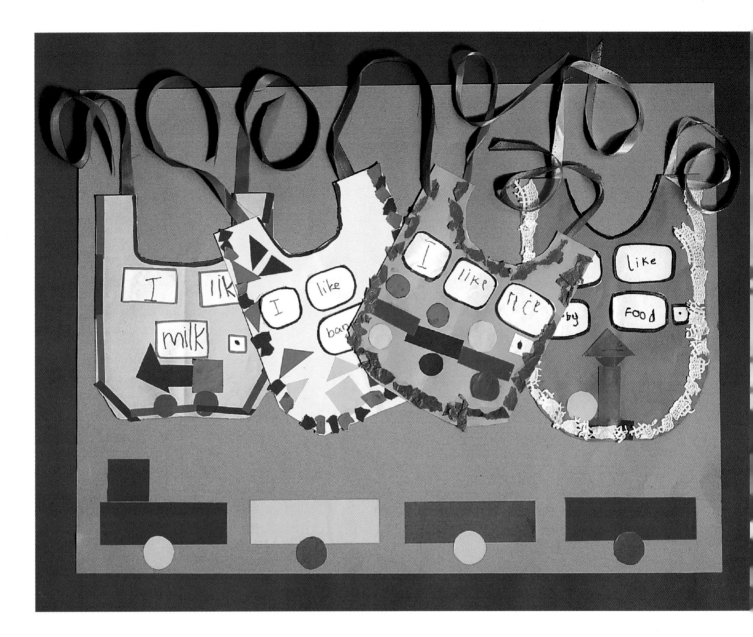

BABIES' BIBS

Materials

Pieces of coloured card
Scraps of coloured paper, tissue paper, doily
Simple sentence, cut up into words

Ribbon, or crêpe paper
Felt-tip pens
Scissors and glue

1. Draw a bib shape on card. Cut it out.
2. Glue the sentence on to the bib.
3. Make a picture (for example, train, kite, lorry) using basic shapes cut from coloured paper, and glue this on to the bib.
4. Decorate the edge using torn scraps or strips.
5. Add ribbons or strips of crêpe paper as ties.

• Adapt for various topics, for example, food, clothing, babies, growth, myself.

• To make a display, bring in real baby items, for example, rattle, bowl, spoon, clothing. Make lists of things that babies like to eat, to play with, to do, to see. Hang the bibs on a line across the display. Include photographs of the children as babies and some of their favourite things. Make a title for the display from squares of paper decorated to look like building blocks, each with one letter on it. Add appropriate pictures from magazines and catalogues.

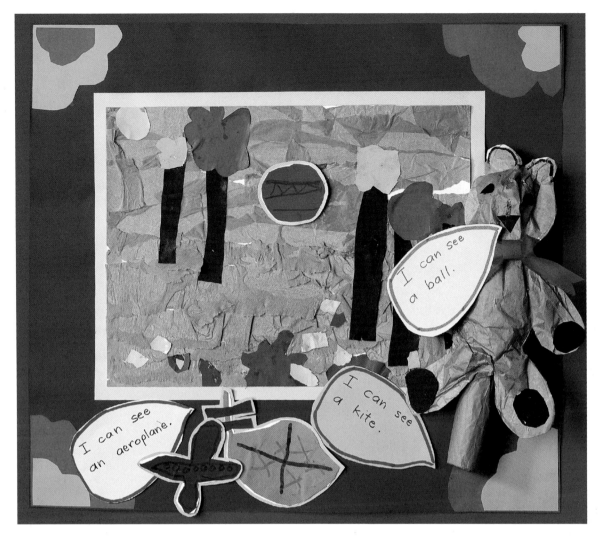

A loop on the background (see No. 7 below) provides storage for the puppet when not in use

PUPPET PICTURE

Materials

for the teddy puppet	Card for teddy bear shape	Adhesive tape
	Brown tissue paper	Thick black felt-tip pen
	Scraps of black paper	Scissors and glue
	Cardboard roll for handle	

for the background Card, torn tissue, crêpe paper

1. Draw a teddy bear shape on the card and go over this outline with a thick black felt-tip pen.
2. Spread glue over the middle of the teddy and press large pieces of crushed tissue paper on to the glued area (avoiding the black line). Leave to dry.
3. Spread glue around the edge of the teddy shape and place a larger piece of tissue paper over the teddy shape, pressing down on the black line. Leave to dry. When dry, trim around the shape.
4. Add details with black scraps and felt-tip pen. Tie a ribbon round the neck.
5. Cover the cardboard roll with tissue paper and attach to the back of the teddy with adhesive tape to form a handle.
6. Background: Make this using the card, torn tissue and crêpe paper.
7. Cut a strip of card and glue both ends on to the picture to form a loop to hold the puppet.
8. Make a variety of objects, for example, kite, balloon, and matching speech balloons. Interchange these as appropriate, using adhesive putty. Match each speech balloon to its object.

• Make different backgrounds for the teddy bear, for example, seaside, city or forest.

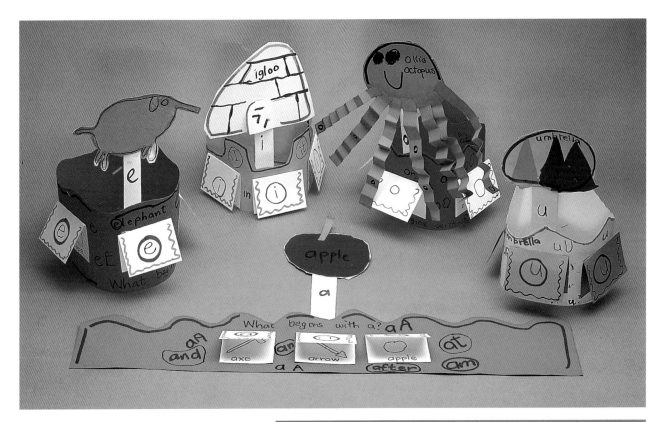

'SOUNDS' HATS

Materials
Coloured card cut into long strips for hats
Pieces of coloured card
Scraps of coloured paper
Felt-tip pens
Scissors and glue

1. Draw and cut out a picture for each of the vowel sounds, for example,
 a - apple, e - elephant, o - octopus, u - umbrella. Decorate them with coloured paper and pens.
2. Attach each picture to the end of a piece of card. Glue or staple this to the hat at the front.
3. Make some small flaps by folding pieces of card in half. Write a vowel sound on the front of each flap, and illustrate each inside. Glue these on to the front of the hat. Label each picture underneath.
4. Decorate the hat with words beginning with the sound. Write a sentence involving this sound.
5. Make it into a hat by stapling at the back (with smooth side of staple on the inside of the hat, to avoid catching on children's hair).

• Play games such as reading each other's hats and guessing what is under each flap.

• Write stories about the characters on your own hat. Try to use as many of the words on the hat as possible.

• Use the same technique for making the hats and apply it to other themes, for example:

animals	**colours**	**names of flowers**
own names	**shapes**	**names of trees.**

• Use for party themes (for example, space, dinosaurs, etc.) and decorate with crêpe paper, tissue paper and glitter.

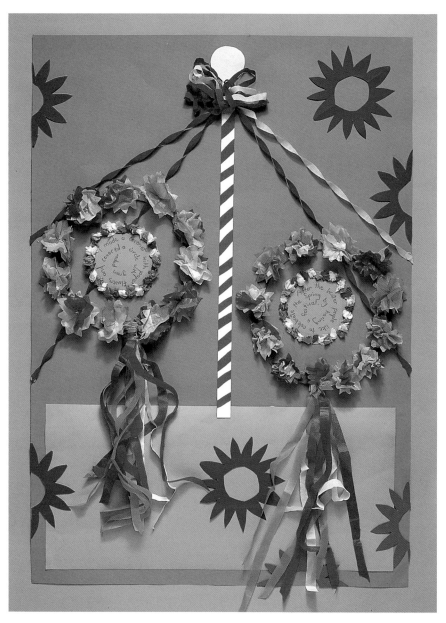

SPRINGTIME DISPLAY

Materials

Turquoise paper for the background
Green paper for grass
Strip of white card for pole
Red, white and purple crêpe paper

Green card for head-dresses
Red, white, pink and purple tissue paper for flowers
Scissors and glue

1. Cut out a ring shape from green card to fit the head.
2. Make flowers from tissue paper by folding circles in half and cutting zigzag shapes around the edge. Gather three circles together and twist at the centre. Glue these on to the circle. Attach strips of tissue paper at the back to make streamers.
3. Cut a strip of red crêpe paper. Glue it at one end and then wrap it around the pole.
4. Cut some narrow strips of crêpe paper. Loop them together at the top and glue on to the pole. Twist each strip several times and glue on to the background.
5. Write stories about springtime on green circles and decorate with tissue paper. Assemble the picture. The hats are part of the display - but are removed for wearing.

• Make similar hats for other seasons of the year - summer, autumn, winter. Use appropriate colours and decorations: *summer* - leaves (in different greens), roses, daisies; *autumn* - leaves, berries, cones; *winter* - icicles and snowflakes.

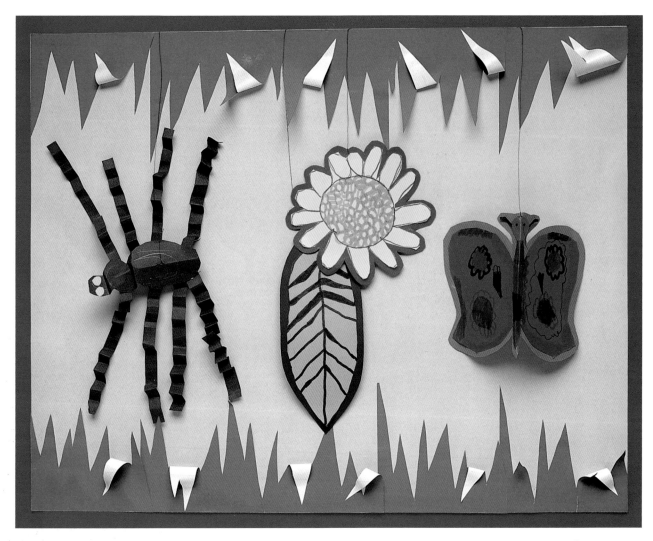

SPIDER ON A STRING

Materials
Black paper or thin card for the spider
Coloured card for flower, butterfly, leaf, etc.
Cotton or thin string
Coloured scraps
Felt-tip pens
Scissors and glue

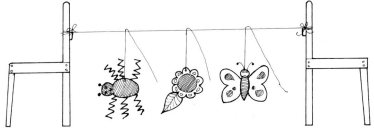

For the spider: Cut a spider's body from the black card. Cut eight narrow strips and fan-fold to make the legs.
For the butterfly: Fold a piece of coloured paper in half. Starting at the fold, draw and cut out half a butterfly shape.
For the flower: Cut out a flower and a leaf shape.

1. Make a hole in the top of each shape and tie a long piece of string or cotton through this.
2. Place two chairs back to back with a short distance between them. Tie a piece of string from one chair to the other. Stand or sit behind the string. Hang the puppets over the string and make each one move up and down, or from side to side, by pulling on the strings.

• Write a script for all the characters and act it out.

• Watch the puppet show being performed and write a story about it.

• Make other characters based on themes, for example, *food, shape, colour, fairy tales, space, historical characters.*

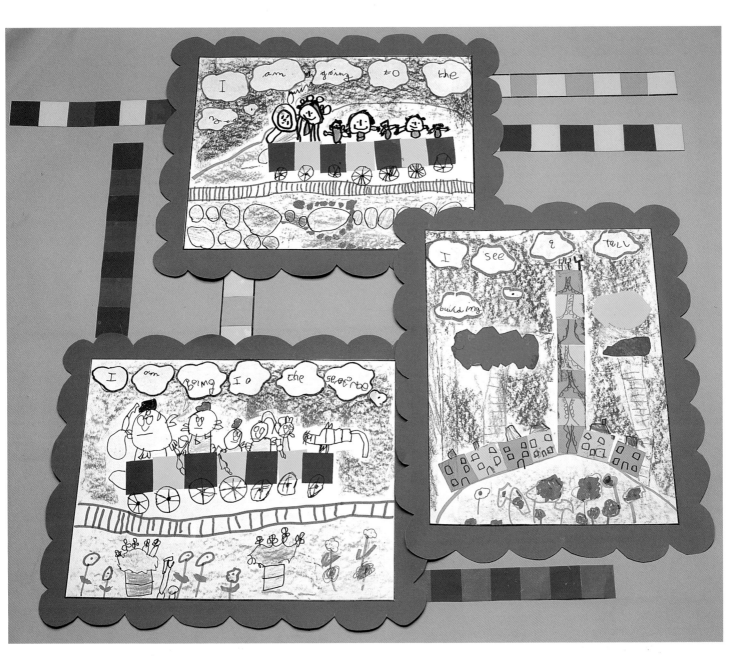

REPEATING PATTERN PICTURES

Materials
White paper for background
Small squares of coloured paper in two colours
Crayons with wrappers removed
Cloud shapes for words

Pieces of coloured paper
Felt-tip pens
Scissors and glue

1. Arrange the coloured squares first to make a repeating pattern, for example, one red, one blue; or two red, two blue, etc.
2. Draw a line across the middle of the background and glue the pattern on to it to make a train, bus, aeroplane, etc.
3. Using felt-tip pens, draw the driver, the passengers and the wheels. If making a train, show how to draw a railway track.
4. Using felt-tip pens, draw objects seen from the window.
5. Talk about where the train is going and write the sentence on the cloud shapes. Glue on to the sky.
6. Using the side of a crayon, colour the sky. Glue on the writing.

• Use other shapes, for example, triangles, rectangles and circles, to create different repeating pattern pictures. Make these into river scenes with boats, or street scenes with lights and cars.

CARTOON CHARACTERS

Draw your own cartoon characters on paper using a black felt-tip pen. Photocopy these drawings in some of the following ways:
- by reducing and enlarging
- by making multiple copies
- by darkening and lightening
- by using coloured paper.

Make pictures using these photocopies.

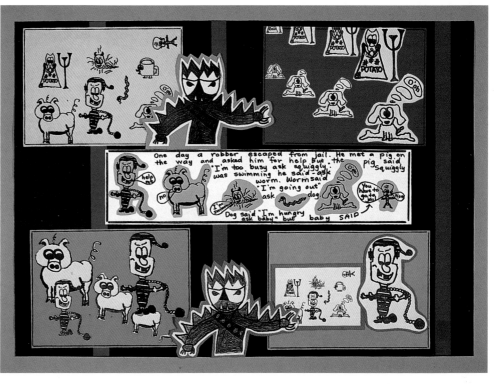

Some ideas for using them:
- Make a story sequence and write about it.
- Make a miniature postcard and write a message.
- Create your own cartoon strip with speech balloons.
- Use pictures to make letter headings and borders.
- Cut out and glue on to a bookmark.
- Design a T-shirt.
- Make your own cards for birthdays.
- Create a 'weekly news' cartoon strip.

STORY STRIPS

Materials

One rectangle of paper for background
One rectangle of paper half the width of the above
One larger rectangle of paper, for mounting
Paper for captions
Ruler, felt-tip pens
Scissors and glue

1. Fold the narrow rectangle of paper in half, then in half again.
2. Keep this folded and cut a shape along the top. Open out, glue on to the background, then on to the mount.
3. Rule lines along the folds to make four panels. Illustrate an action in sequence with felt-tip pens.
4. Write a story or captions on paper, cut out and glue under the pictures.

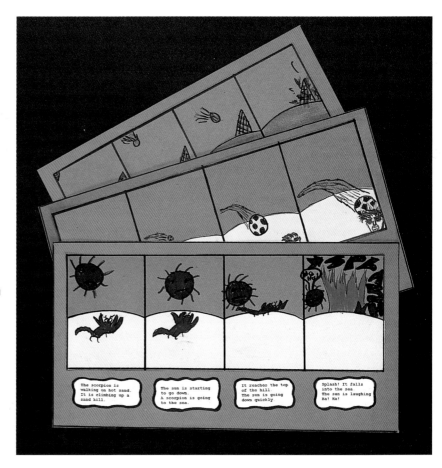

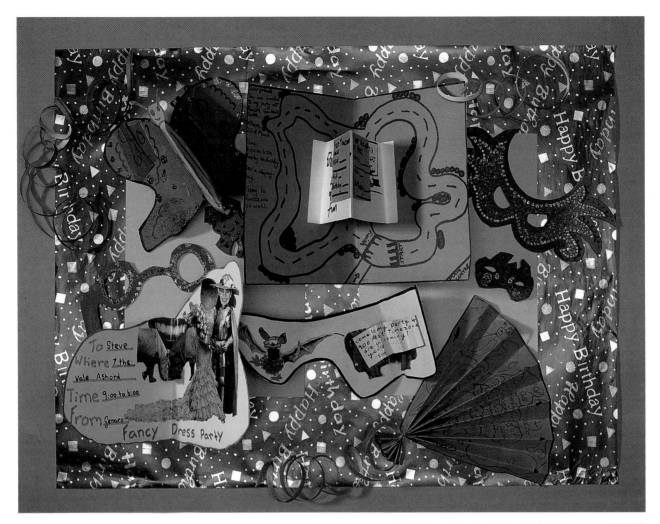

INVITATIONS

Materials
Pieces of coloured card
Magazines
Scraps of coloured paper
Felt-tip pens and glitter pens
Scissors and glue

Using scrap paper, experiment with pop-up card designs. Create your own versions of ways to make pictures pop up. Design an invitation for a birthday party which has a 3D element, for example, pop-up, folded, etc. Decorate using scraps, magazine pictures and pens.

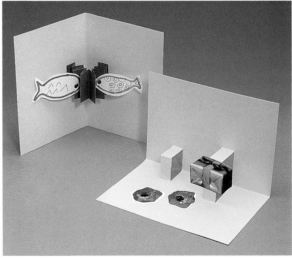

Two examples of simple pop-ups

• Use the invitation to suggest a theme for a party, for example, mask, fantasy, animal, cartoon, computer game, etc. Plan food, decorations, costumes, etc., around the same theme.

• Make an invitation in the form of something to wear, for example, headband, bracelet, badge, etc.

• Use this idea at Christmas time for the class party. Each person draws a name out of a hat and creates an invitation for that person. Discuss ideas for pop-up Christmas cards: for example, Father Christmas coming out of the chimney, a toy coming out of a cracker. Use Christmas wrapping paper to make an envelope and decorate it to match. Design a stamp and glue it on.

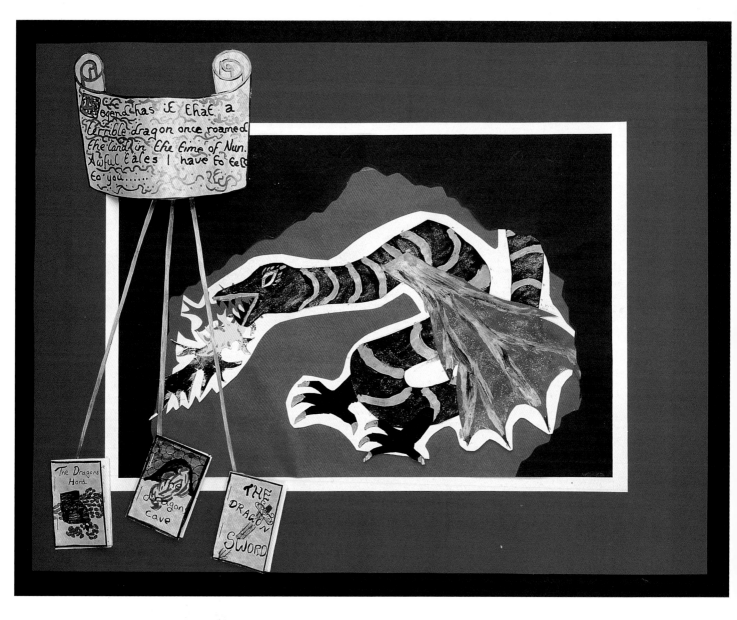

DRAGON IN A CAVE

Materials

Coloured paper for dragon and background
Black paper for cave
White paper for dragon outline
Small pieces of coloured paper
 for flames and decoration

Glitter pen, gold pen (both optional)
Paper for scroll and books
Felt-tip pens
Scissors and glue

1. Draw a dragon on black paper. Cut it out and decorate with gold pen, glitter pen, etc. Make wings and flames.
2. Glue it on to white paper and cut around, leaving an edge.
3. Cut a cave entrance from the black paper. Glue the dragon and cave on to the background.
4. Make a scroll and individual miniature books of dragon stories. Decorate the covers with gold pen and felt-tip pens.

• Find a way to make a dragon move in and out of a cave.

• Look through books to find dragons from other cultures. Write stories about these dragons.

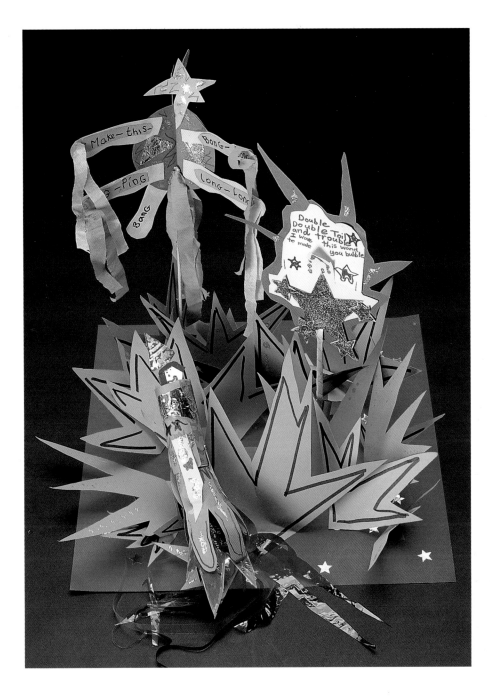

3D 'SPELLS'

Materials

Pieces of coloured card
Scraps of Cellophane, tissue paper, crêpe paper,
 coloured paper
Junk materials, sticks, straws

Glitter pen, metallic pens
Felt-tip pens
Scissors and glue

1. Look at the designs in the picture and cut a basic shape from card. Add any of the materials from the above list and decorate to create a 3D 'spell'. The spells look more effective when all the junk materials have been covered with coloured paper first.
2. For a different design, use a cardboard roll covered with coloured paper (for example, tissue paper). Add Cellophane streamers and shapes cut from coloured card. Discuss ways to make the spells work (for example, shaking, blowing, waving, tapping, etc.). Glue on to a stick or covered ruler if desired. Write a spell on the 3D shape using felt-tip pens.

• Make an interesting container in which to keep your spell.

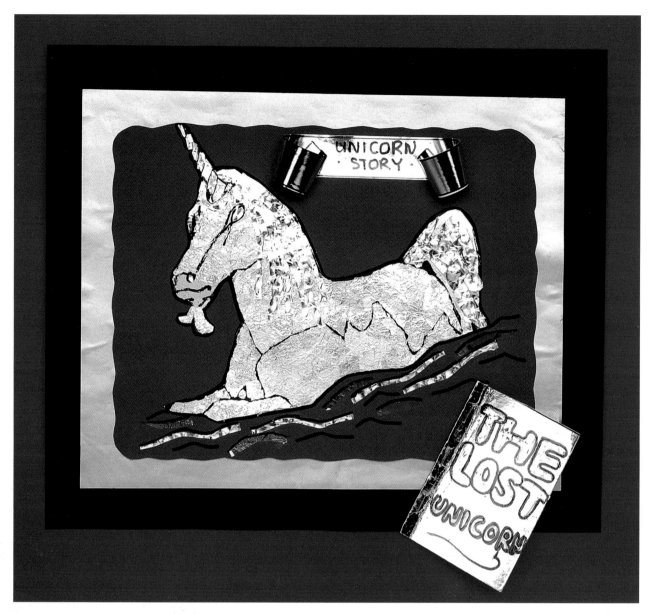

SILVER UNICORN

Materials
A piece of paper (any colour) for unicorn
Blue paper for background
A variety of silver papers, for example, kitchen foil, chocolate wrappings, wrapping paper, etc.
Silver card or card covered with silver paper
Paper for book pages
Black marker pens
Scissors and glue

1. Draw a picture of a unicorn on a piece of paper, and cut it out. Cover with glue and press pieces of silver paper (cut or torn) on to the shape.
2. Turn the shape over, and trim the edges. Add details using other silver papers.
3. Glue on to the background.
4. Make a small silver book to match the unicorn. Decorate with marker pen and write your own legend about a unicorn.
5. Glue some silver papers back to back. When dry, cut a strip, roll the ends back and glue these to make a scroll.

• Make other creatures using gold papers. Make them stand out from the background.

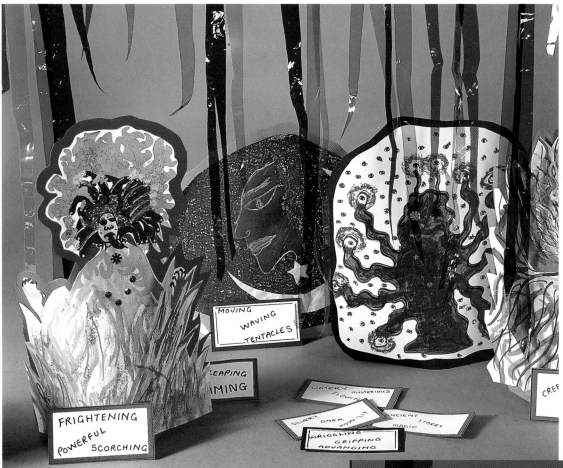

FANTASY CREATURES

Materials
Coloured or white paper
Coloured card
Small cardboard boxes
Glitter pens and gold pens (if possible)
Shiny scraps (for example, sequins, beads)
Felt-tip pens
Scissors and glue

1. On the coloured or white paper draw a fantasy creature based on a theme, for example, *underwater, forest, space, fire.*
2. Decorate using a variety of pens and shiny scraps. Cut around the edge.
3. Glue it on to a piece of coloured card, keeping the lower edge straight.
4. Attach this shape to the front of a box or other container.
5. Make small cards in matching colours and write some descriptive words for each creature. Place these in the appropriate boxes and use them for story-writing or poetry.

• Make characters based on different topics, for example, *space, television personalities, book characters, historical periods.*

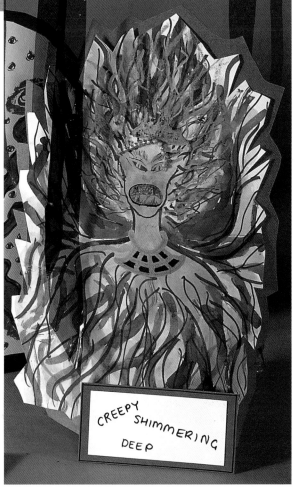

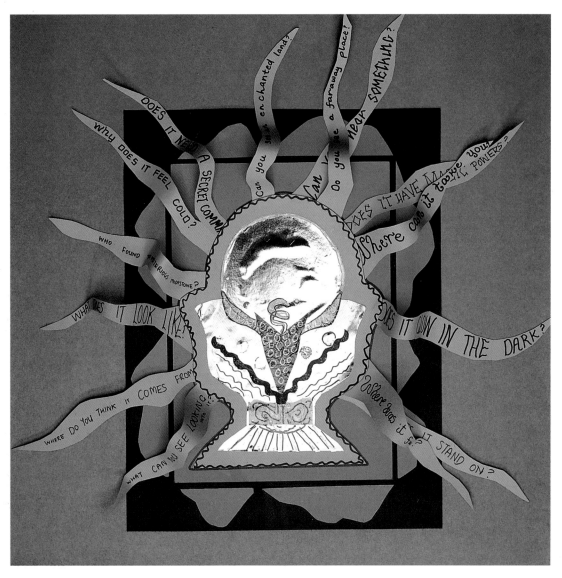

MYSTERIOUS MOONSTONE

Materials

Pieces of coloured card for background and mount
Silver paper for moonstone
Piece of paper for moonstone holder
Card for background

Shiny scraps, pieces of foil
Strips of card (cut into pointed shapes)
Felt-tip pens
Scissors and glue

1. Cut out a circle from the silver paper to represent the moonstone.
2. Cut out a shape from paper to make the moonstone holder, and glue on pieces of shiny scraps, foil, etc.
3. Decorate using pens. (Marker pens and metallic pens can be used to draw on foil.)
4. Glue the moonstone and the holder on to coloured card and cut around it, leaving a narrow edge.
5. Ask questions about the moonstone. For example:
 > *Who found it?*
 > *Does it have any special powers?*
 > *Can you see any faraway places in it?*
 > *Does it glow in the dark?*
 > *Where was the moonstone found?*
 > *Does it need a special command to activate it?* etc.

 Write these on the pointed strips of card.
6. Glue the moonstone and the holder on to the background card, leaving spaces to insert the question strips. These can then be removed and used to write stories or poems.

• Create other special stones, for example, emeralds, sapphires, diamonds, rubies.

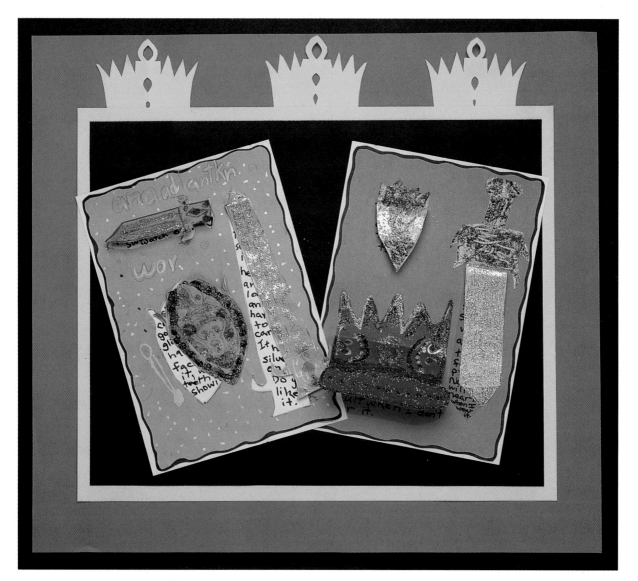

SWORDS AND SHIELDS

Materials
Two sheets of coloured paper in contrasting colours
Glitter pens (or glitter and glue)
Felt-tip pens
Scissors and glue

1. Draw a sword and a shield on one of the sheets of paper. Decorate
 them with glitter pens and felt-tip pens.
2. Cut around these shapes, leaving a small part of them joined to
 the piece of paper (as shown in the photograph).
3. Spread glue around the edges of the other sheet of paper
 and place the decorated one on top.
4. Lift up the shapes and write in the spaces
 underneath about the objects.

• Use this technique for a variety of
 themes. Make on a larger scale for
 wall display.

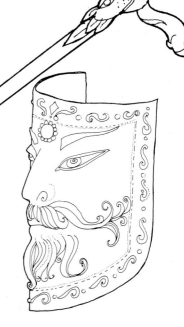

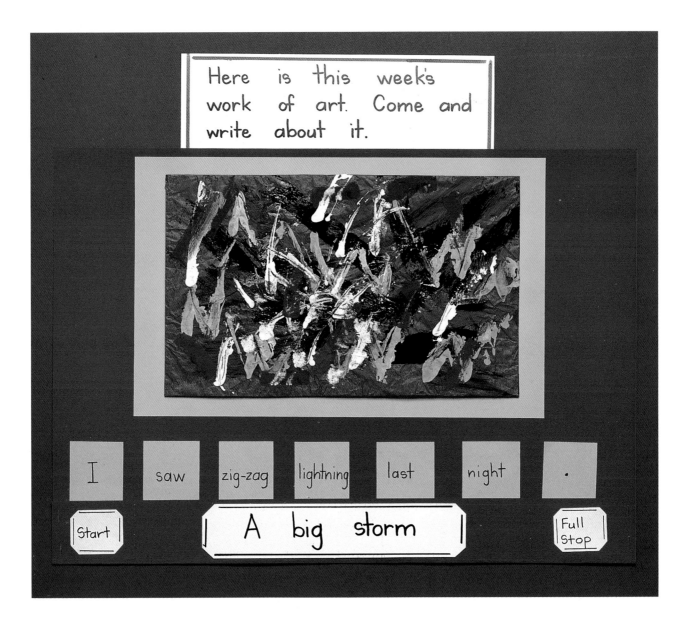

SENTENCE CHANGER

Materials
Large piece of coloured card
Smaller pieces of coloured card
Long-armed stapler
Felt-tip pens

1. Fold up the lower part of the large piece of card and staple at intervals to form pockets.
2. Using a contrasting colour, cut several cards of the same size to fit the pockets.
3. Attach a piece of artwork so that it can be replaced easily, using an adhesive putty, or paper clips. To make the storm picture shown in the photograph, cover a piece of paper with tissue paper and fold the surplus on to the back and glue down. Using thick paint and some objects for printing (for example, ruler, small roller, straws), create an abstract painting.
4. Write a sentence about the picture on the small cards and put the cards in the pockets.

• Change artwork and sentences every few days.

• Make individual or group sentence changers for topics.

• Use this idea to make a weather chart.

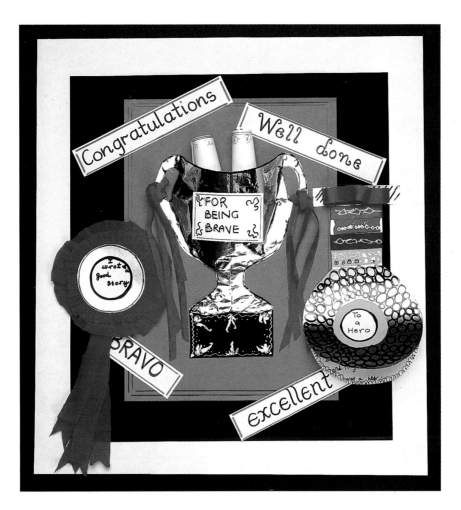

TROPHY

Materials

for the trophy

Coloured paper for background
Silver paper, black paper
Red ribbons or strips of crêpe paper
White paper for writing

for the medal

Gold paper or card, scraps of coloured paper
Paper for writing

for the rosette

Circle of card for writing
Circle of silver paper, larger than the above
Strips of red crêpe paper - one narrow, one wider

Also: silver pen, marker pen, scissors and glue

Trophy. Fold the silver paper in half and draw half a trophy shape. Cut this out and glue on to the background. Make it stand out by gluing at the sides only. Cut out a black base, attach it to the trophy and decorate with silver pen. Write about why you have received this award, then roll up your page of writing and place it in the trophy.

Medal. Cut out a medal shape from gold card, then one from writing paper to fit underneath. Glue these together at the top. Decorate the medal with coloured paper and marker pen. Write a story of bravery on the writing paper under the medal.

Rosette. Spread glue round the underside of the silver circle and pleat the narrow red strip on to this. Add more glue and repeat with the wider strip. Turn over to the front and add the circle of writing paper. Write an appropriate message on this.

WORD BANKS
These word banks will help young children to locate words when writing independently.

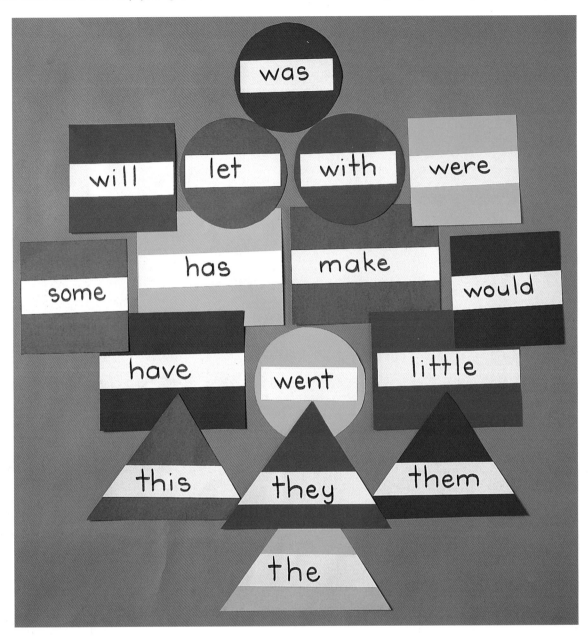

GEOMETRIC SHAPES

Materials
Coloured card for background
Card in four colours - blue, red, yellow, green
Strips of white paper for words
Paper trimmer

1. Draw and cut out a circle from each of the colours.
2. Repeat with triangle shapes.
3. Using the paper trimmer, cut four rectangles and four squares from each of the four colours.
4. Write words on the white strips and glue on to the shapes.
5. Glue the shapes on to a background.
6. Each word is found by shape and colour. For example, 'Where is the word *make?* 'It's in the green rectangle.'

• To use this word bank the children will need to be familiar with the four colours and geometric shapes.

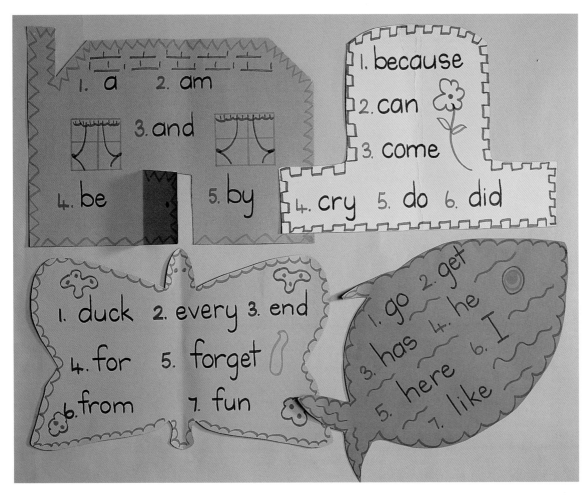

'OUTLINE' WORD BANKS

In the photograph above, the common words are arranged within picture outlines, and located by number. For example, 'Where is the word *every?*' 'It is number two in the butterfly'.

- As an activity to familiarise children with these words, draw these picture outlines on work cards, write the numbers on these and leave a blank space for the words to be written; or vice versa, with the words written and empty boxes in which to write the numbers.

WORD GARDEN

The sunflowers are made by cutting circles of card and petal shapes and gluing the petals around the edge of the circle. Pieces of black torn paper are glued around the edge of the circle. Words can be written on each side of the flower.

Attach strips of green crêpe paper to the flowers and hang these from the ceiling or a line.

Words can be located by placing numbers, or pictures of animals, etc., at the top of each stem.

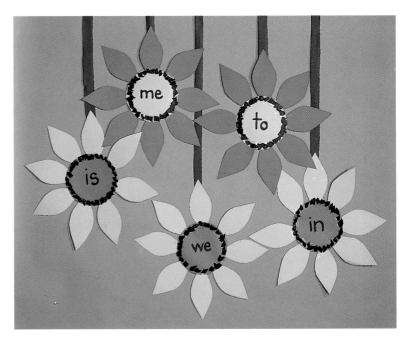

51

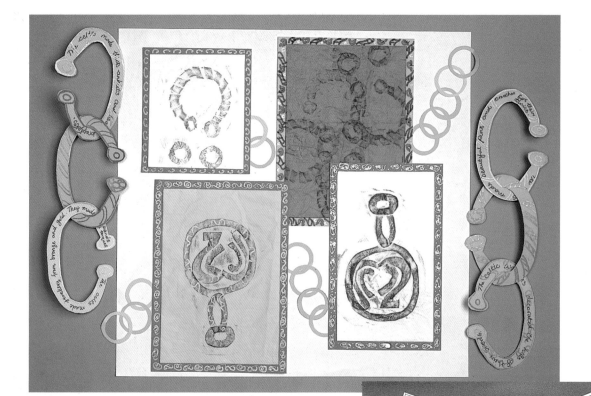

CELTIC JEWELLERY

Most Celtic jewellery was made from bronze or gold which was melted and poured into moulds. Using these moulds, the Celts made intricate and decorative patterns on their jewellery. They also made patterns by engraving and embossing. They wore *torques* which were neckbands made of twisted strands of gold (see line drawing on page 68).

Tissue paper and rubbing picture

- Look at pictures of Celtic jewellery and mirrors. Draw and cut out some shapes from card. Glue these on to a piece of paper to make a mirror and torque **(see page 68)**. Add a rim around the edge of the shapes to emphasise the outline. Leave to dry. **(See small photograph above.)**
- Place a piece of tissue paper over the cardboard shape. Using the side of a thick crayon (with wrapper removed), rub on the tissue paper over the shape. Repeat with a different colour to give a brighter effect. Glue the tissue paper over a piece of card. Decorate with metallic pen to complete the picture. Cut out torque shapes from yellow card. Decorate with gold pen and write about Celtic jewellery on the reverse side. **(See main photograph above.)**

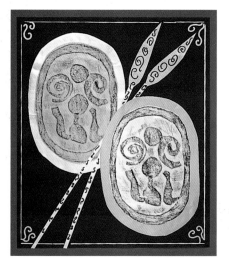

CELTIC SHIELDS

Use the same rubbing technique as above, with black and dark brown crayons on silver and gold paper. **(See page 68 for a Celtic shield design.)** Cut around the rubbed shields and mount each on the contrasting colour.

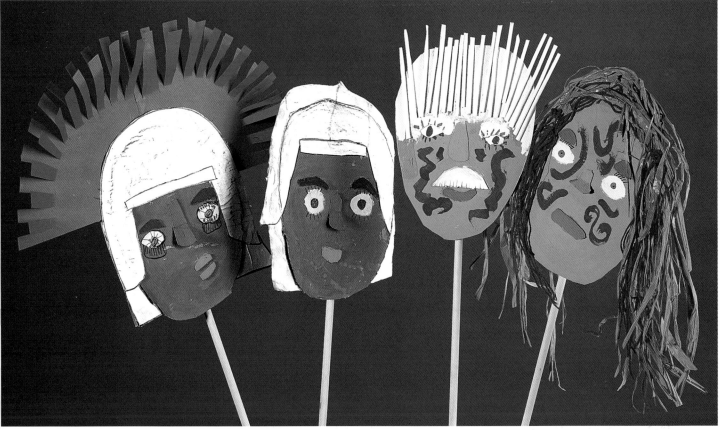

Roman heads on the left, Celtic heads on the right - can be used as props for drama

CELTIC HEADS

To make themselves look more fierce, the Celts decorated their faces and bodies with patterns made from a blue dye called *woad*. This came from the leaves of the woad plant.

Materials

Pieces of stiff card
Raffia and wool (red, brown, orange)
Art straws painted white
Thick paint in various colours - for faces and features

Paintbrushes - thick and thin
Adhesive tape
Stick for handle
Pencil, scissors and glue

1. Draw a face shape on the card.
2. Draw and cut out features from scraps of card. Paint these separately with thin brushes and leave to dry.
3. Paint the faces using thick brushes. When dry, add woad patterns and glue on features.
4. Glue on raffia and wool or straws for hair.
5. Write about this character on a piece of paper and glue on to the back of the head.
6. Add the stick with adhesive tape.

Some popular Celtic names: Brian, Gavin, Duncan, Gareth, Enid, Deirdre, Morwenna, Muriel.

ROMAN HEADS

Roman heads are made the same way, using silver paper and red card for the helmets.

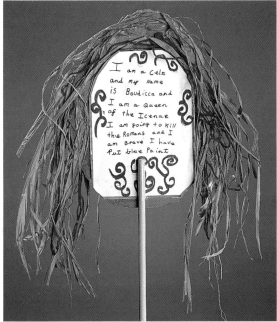

Back of one Celtic head, showing written work, which can be read aloud

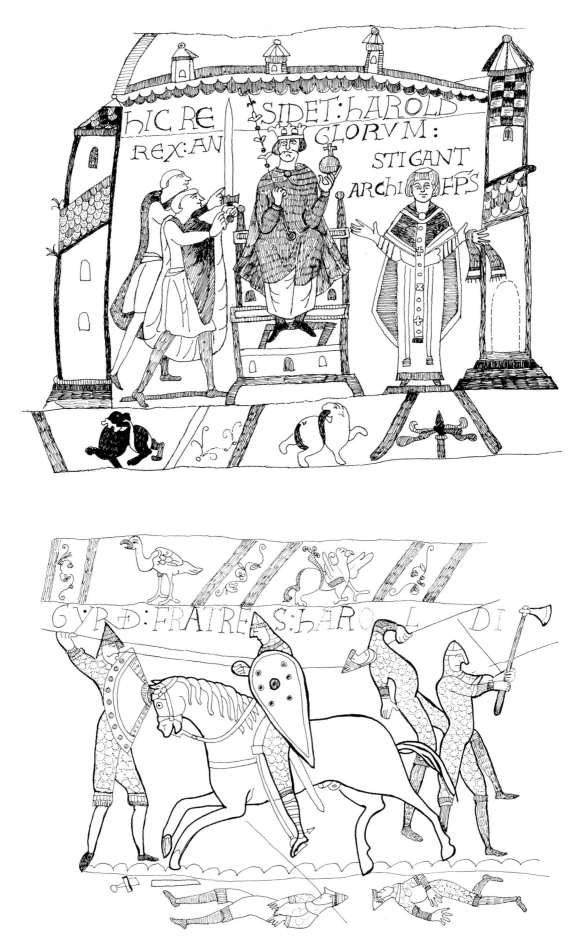

Artist's impression of scenes from the Bayeux Tapestry - see a further example on the title page of this book

54

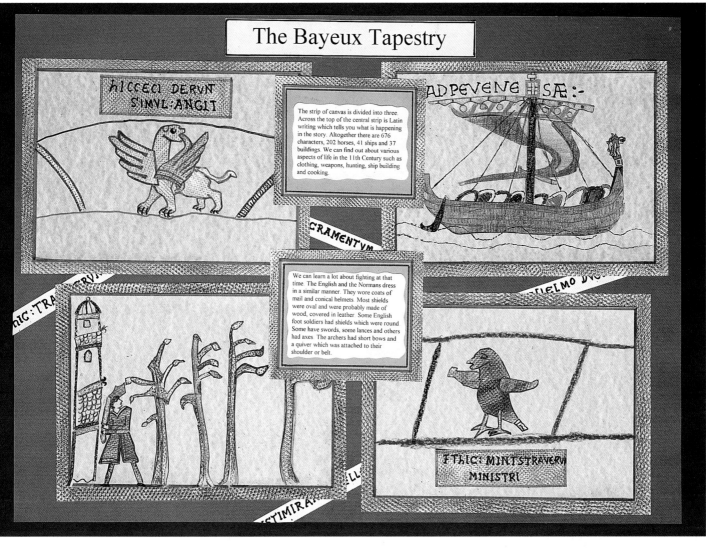

BAYEUX TAPESTRY

The Bayeux Tapestry is not actually a tapestry, but an embroidery. Instead of being woven it was stitched with wool on linen. It is approximately 70 metres long and 50 centimetres wide. It tells the story of William the Conqueror's victory over the English king, Harold. The tapestry covers events from 1064 to 1066, and shows us about life in the 11th century. It tells us about clothing, horses, weapons, hunting, shipbuilding and cooking.

Materials

Cream paper for background

Thin white paper (for rubbing)

Crayons (with paper wrappers removed) in appropriate colours, for example, light brown, dark brown, green and black

A textured surface (with close pattern, for example, plastic garden mesh) for rubbing

Felt-tip pens (in same colours as the crayons)

Scissors and glue

1. Using the side of a crayon and a sheet of white paper, rub the textured surface in one of the colours above. Repeat on other sheets of paper with the other coloured crayons.
2. To give a more interesting effect, rub over with a second colour, for example, black on dark brown.
3. Using the rubbed papers, draw and cut out figures and objects copied from the Bayeux Tapestry.
4. Glue these on to the cream paper, and add details in felt-tip pen to recreate a scene from the tapestry.
5. Rub a larger piece of white paper on the textured surface and glue the scene on to this leaving a border or mount around the edge.

• Use this rubbing technique to make a class 'tapestry' to show recent events in the school.

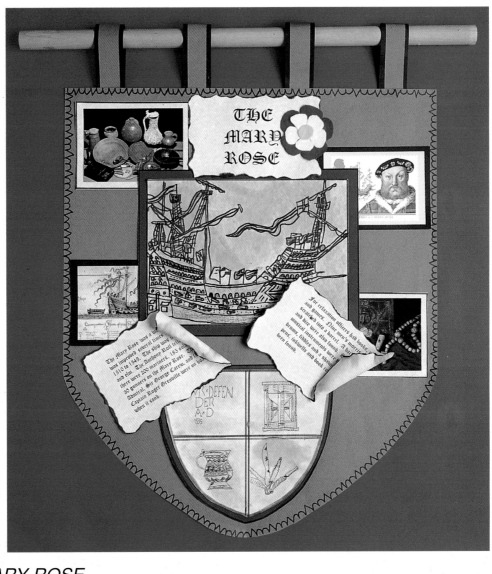

THE *MARY ROSE*

The *Mary Rose* was part of King Henry VIII's fleet of ships. It was during a battle with the French in 1545 that she sank - two kilometres from Portsmouth Harbour. Henry VIII and many important people had come to see the fleet leave, and they witnessed the tragedy. One eyewitness report said that 700 men were on the ship when it sank. Many of them were unable to escape because of the netting which was strung across the ship. It was thought that the combination of overcrowding and indiscipline caused the ship to tilt, and then sink. After many years of excavation, it was lifted from the sea-bed in 1982. It is now in a museum in Portsmouth, England (The Mary Rose Trust).

A lot has been learnt about Tudor times from studying the many artefacts found on board the ship - for example, the tankard shown in the line drawing below. (For an artist's impression of the ship, see page 69.)

MARY ROSE DISPLAY

Materials

Brown paper cut in a pennant shape for background
Cream or beige paper for drawing, writing and labels
Felt-tip pens in black and brown
Scissors and glue

1. Wash over a piece of paper with a tea-bag. Leave it to dry and draw a picture of the *Mary Rose* on the paper. **(See page 69.)**
2. Write about the ship in an old-fashioned script, or use an appropriate font on a computer. Burn around the edge with a candle **(adult supervision necessary)** to age the paper.
3. Display pictures, text, etc., on the pennant and add hanging straps, rod, and a Tudor rose.

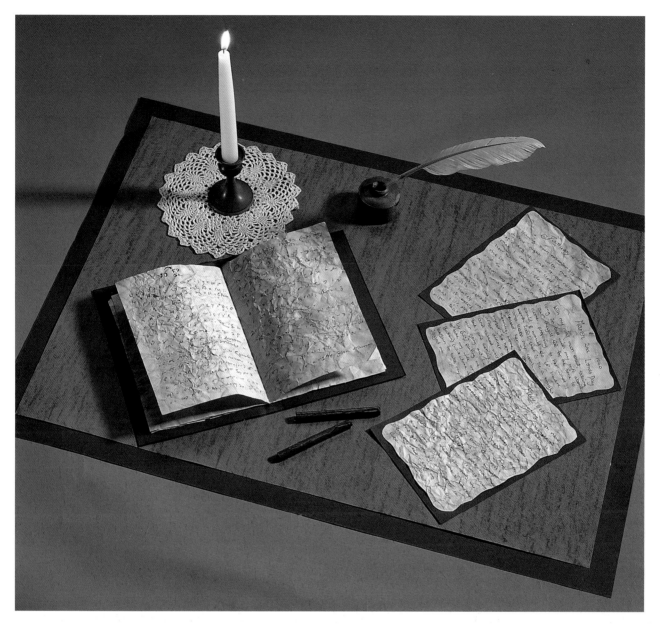

SAMUEL PEPYS' DIARY

Samuel Pepys started writing his diary in 1660 when he was 27. He wrote in it every day for nine years except for eleven days in 1668 when he was on holiday. It was written in shorthand with a few words written in longhand. He never corrected it and always wrote it soon after the events.

He always wrote in the diary by candlelight and had to stop finally because he was afraid of losing his eyesight. He wrote about the following:

- his clothes, food, health
- his love of music
- his work as 'Clerk of the Acts to the Navy Board'
- secrets and bribes
- scenes of life - at King Charles II court, London in the fire and plague
- his observations of people
- his wife.

To make the diary
1. Wash over white paper with tea or coffee bags. Scrunch the paper into a ball and put in a microwave oven for approximately one minute **(with adult supervision).**
2. Open out the paper and iron it flat. Repeat with other pages.
3. Stitch the pages together to make a book.
4. If desired, invent your own shorthand, adding a few longhand words. Write with black fine-line pen.
5. Make a cover with black or brown paper.

VICTORIAN ALPHABET

The alphabet in the photograph above is based on one in a child's copy-book of the 1870s. Children were expected to reproduce each image in a box underneath as a way of learning their alphabet.

K **M** **U**

Examples from a Victorian alphabet

- Make a list of suitable words for each letter of the alphabet. Decide which would be the most fun to do, and design your own Victorian-style alphabet.
- Invent a modern day alphabet using cartoons or computer images. Draw the letters with a light pencil then decorate with pen in the shape of the letters.

- Look at other ways children learnt the alphabet last century, for example, with building blocks, rhymes, samplers. Invent a game for learning the alphabet in modern times. Try it out with a young child and see if it is fun to play.

Invent your own decorated alphabet

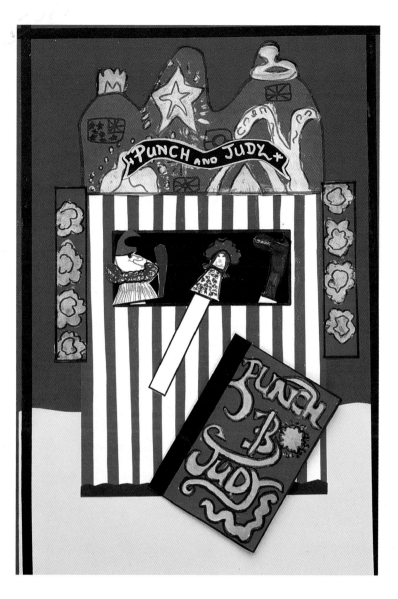

PUNCH AND JUDY

The Punch and Judy show was a travelling puppet theatre. It was first recorded in the original publication of Samuel Pepys' diary. He said it was the best puppet show he had ever seen. It was based on Punchinello, an Italian clown. Some of the characters are Mr Punch, Judy (his wife), Toby the dog, the baby, the policeman and the crocodile.

INDIVIDUAL PUPPET THEATRE

Materials
Blue paper for background
Yellow paper for sand
Red paper and white strips for puppet theatre
Scraps of card for puppets
Felt-tip pens and metallic pens
Scissors and glue

1. Cut a rectangle from red paper and glue on the white stripes. Fold in half and, starting at the fold, cut out the opening.
2. Glue the puppet theatre on to the background of blue and yellow paper and cut a slit through the blue paper at the bottom of the theatre opening to allow the puppets to be pushed through from the back.
3. Make the puppet figure from card and glue on to a strip of card.
4. Add details to the picture with pens and paper.
5. Make a small book for writing the script of *Punch and Judy*.

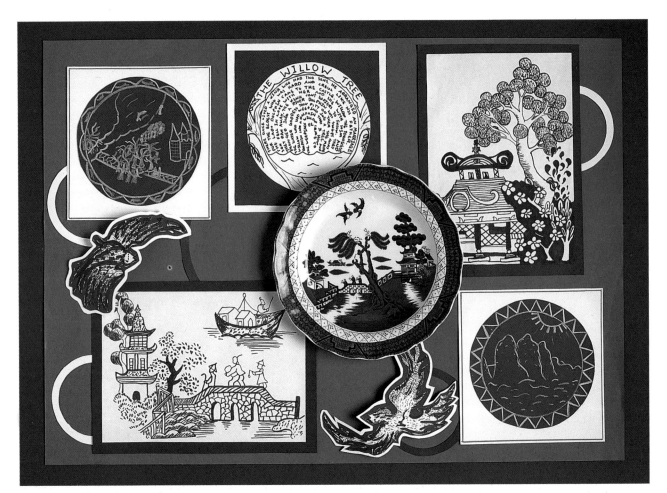

WILLOW PATTERN PLATE

A young potter called Thomas Minton designed this pattern in Staffordshire, England, in about 1780. It was based on an old Chinese story about a rich Mandarin, his daughter and his secretary. The daughter and secretary eloped together and the Mandarin chased them across a bridge but, before he could catch them, the Gods changed them into birds and they flew away.

Materials
Papers in blue and white Blue felt-tip pens
White crayons A willow pattern plate (if possible)

1. Using blue felt-tip pen, draw a scene from the willow pattern story.
2. Cut out circles from blue paper, and draw your own legend in white crayon.
3. Using a white circle and blue pen, write your own legend.

For display
Mount white circles and pages on blue background, and vice versa. Add details such as birds, a bridge, the willow tree, etc.

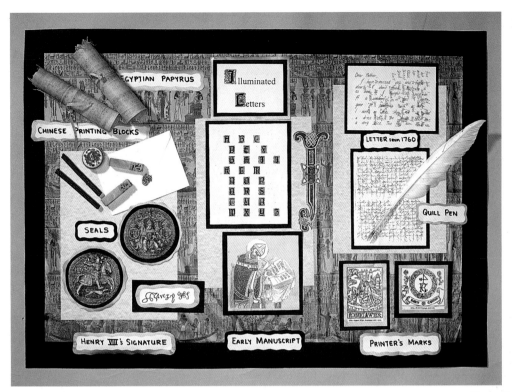

See also page 2

MAKING A MARK

This display shows some ideas and artefacts connected with writing through the ages. Ask children to bring in objects connected with this topic. The display above (shown also on page 2) includes the following:

Papyrus

This was an early form of paper made by Ancient Egyptians from the papyrus plant. Pens were sharpened twigs or reeds, and paint made from red and black powders was used as ink.

• To give a papyrus effect, wash over white paper with thin yellow paint. When it is dry, rub over with the side of a light brown crayon.

Chinese printing blocks

These are made from onyx which has been cut into a cuboid shape, and the end chiselled to carve a name. To print this design, the block was pressed into a small decorated pot containing red ink.

• Make a Chinese printing block, or 'chop', using clay, and decorate one end with a pattern.

Seals

In early times, seals gave authority to legal documents. They were made by heating sealing wax, pouring it on to the document and pressing an engraved design into it. **(See an example on page 70.)**

• To make a seal, flatten a piece of modelling material into a disk shape. Using a sharp pencil, press out a design. Leave it to harden, and glaze over with diluted glue.

Printers' marks

These were woodcuts (and, later on, metal plates) which early printers used to identify their work. **(See an example on page 70.)**

• Design your own printer's mark, using your name or initials.

Criss-cross letters

In the past, because paper was expensive, letters were written across the page - and then down the page, across the horizontal text. Later, this saved money on postage.

• Look at writing from other countries **(see pages 65 to 67)**.

• Find out about scripts written from right to left, or up and down.

Illuminated Letters

These are found in medieval manuscripts. At the start of a book or section, the initial of the first word was elaborately decorated.

• Create your own illuminated letters based on the letters shown on page 63. Use gold and blue pens to decorate them.

BRAILLE

Louis Braille invented an alphabet so that blind people could read and write.

He was born in Paris in 1809 and lost his sight at the age of three after an accident in his father's shop when a saddlery tool slipped and pierced one eye. He eventually lost the sight in both eyes. He was an excellent student and became a teacher at the Royal Institute for Blind Children in Paris. His system of communication is still used today all round the world.

Raised dots are used to represent the letters of the alphabet. People who are blind can read by touching the raised dots. Braille can be written by punching a stylus through a frame on to the paper. Nowadays, there are computerised machines for writing braille.

• Children can write their own messages or short stories using the braille alphabet.

• Make a list of where braille would be appropriate to use in public places, for example, in lifts or leisure centres.

ILLUMINATED LETTERS

These letters can be photocopied and then decorated. Alternatively, they can be used as an inspiration for your own designs.

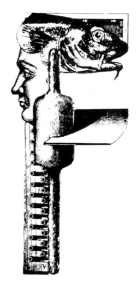

LETTERING

Experiment with computer fonts to add variety to your text; or use these as a stimulus for creating your own script. The samples shown could be enlarged on a photocopier for younger children to copy or trace.

ABCDEFGHIJKLMNOPQR
STUVWXYZ Averoigne

ABCDEFGHIJKLMNOPQRS
TUVWXYZ Chaillot

ABCDEFGHIJKLMNOPQRSTUV
WXYZ1234567890 Kanban

ABCDEFGHIJKLMNOP
QRSTUVWXYZ1234567890
abcdefghijklmnopqrstuvwxyz Old English Text

ABCDEFGHIJKLMNOPQRST
UVWXYZ1234567890
abcdefghijklmnopqrstuvwxyz ScruffPlain

ABCDEFGHIJKL
MNOPQRSTUVW
XYZ Tenderleaf - Caps

LABELS IN OTHER LANGUAGES

Each of the sentences below, and on the following two pages, means 'I like writing'. They are arranged in alphabetical order of the language names.

Photocopy these to make labels of other languages for wall displays or on a writing table.

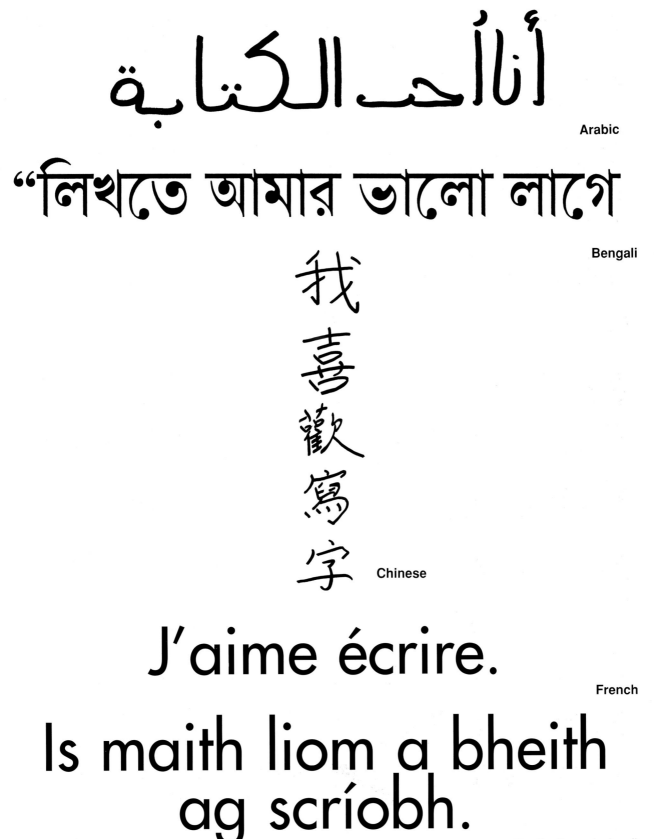

Arabic

Bengali

Chinese

J'aime écrire.

French

Is maith liom a bheith ag scríobh.

Gaelic (from Ireland)

'S toigh leam sgrìobhadh.

Ich schreibe gern.

ΜΟΥ ΑΡΕΣΕΙ ΝΑ ΓΡΑΦΩ

'મને લખવાનું ગમે છે. લખવુ તે આનંદ છે'

'मैं लिखना पसंद करता/करती हूँ ।

Mi piace scrivere.

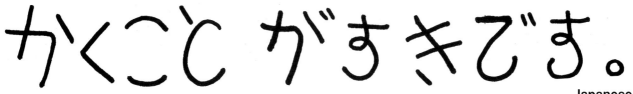

Japanese

나는 쓰기를 좋아합니다.

Korean

Me gusta escribir.

Spanish

எனக்கு எழுத விருப்பம்.

Tamil

میں لکھنا پسند کرتا ہوں۔

Urdu

Mepɛ Kyerew.

Twi

'rwy'n hoffi ysgrifennu.

Welsh

CELTIC JEWELLERY AND ARTEFACTS

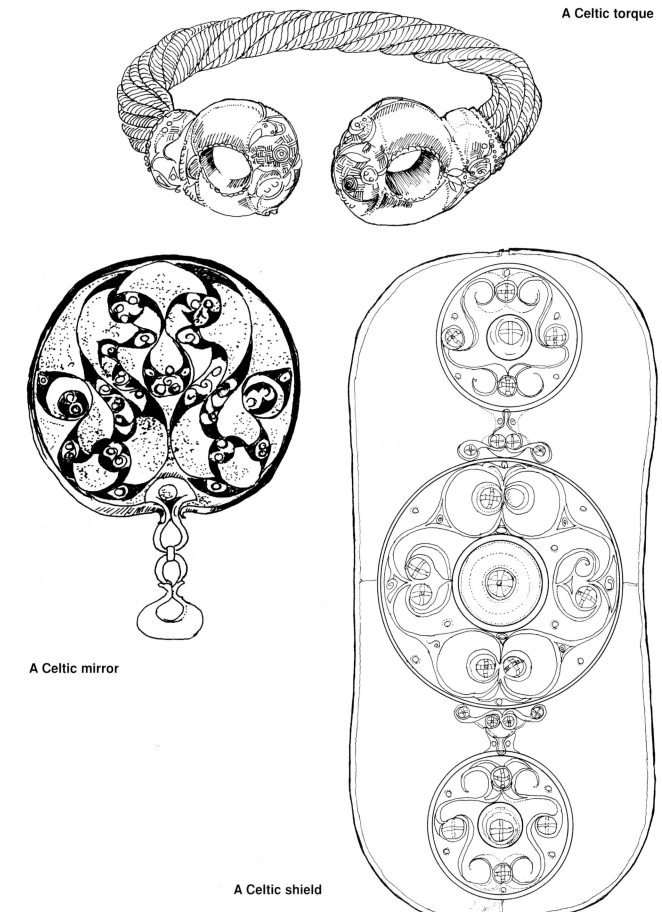

A Celtic torque

A Celtic mirror

A Celtic shield

THE *MARY ROSE*

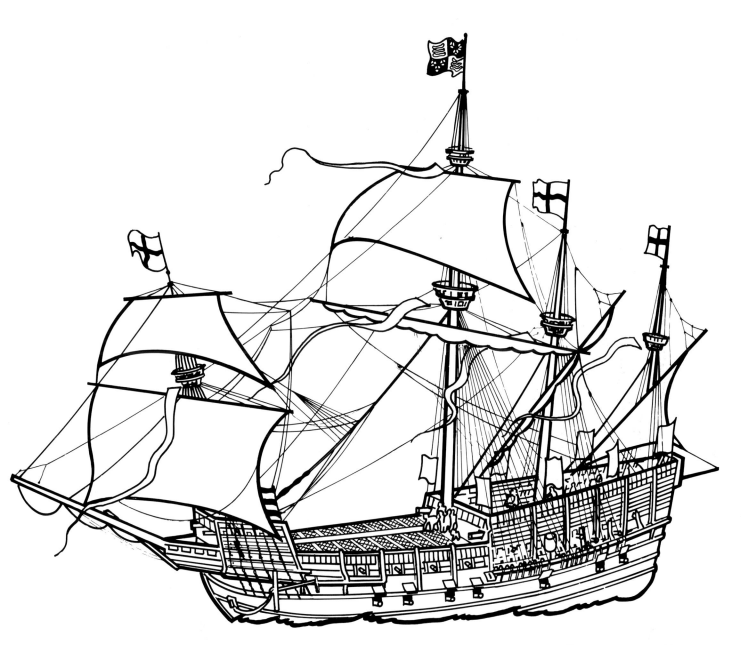

The *Mary Rose*, see page 56

This drawing of the *Mary Rose,* provided by The Mary Rose Trust in Portsmouth, shows how the ship would have looked prior to her sinking in 1545, based on the evidence contained in the surviving structure of the hull. She was built of oak with an elm keel in 1509-1511.

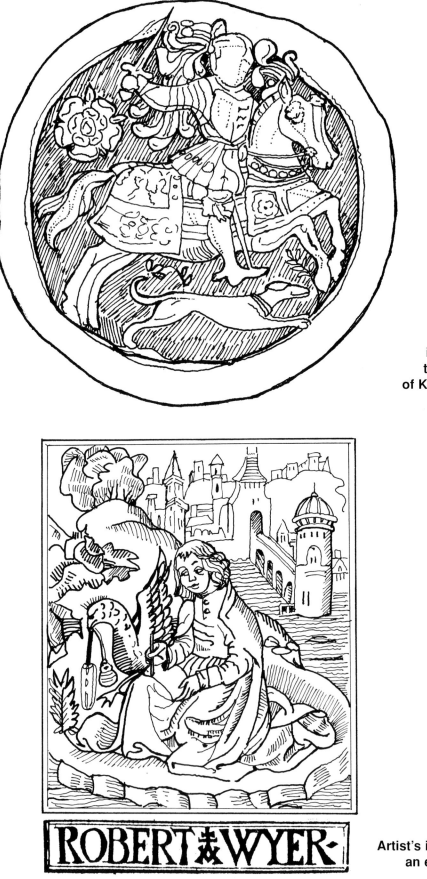

Artist's impression of the Great Seal of King Henry VIII

ROBERT WYER

Artist's impression of an early printer's mark

For details of further Belair publications,
please write to Libby Masters
BELAIR PUBLICATIONS LIMITED
Albert House, Apex Business Centre
Boscombe Road, Dunstable, LU5 4RL
United Kingdom

For sales and distribution (outside North America)
FOLENS PUBLISHERS
Albert House, Apex Business Centre
Boscombe Road, Dunstable, LU5 4RL
United Kingdom

For sales and distribution in North America and South America
INCENTIVE PUBLICATIONS
3835 Cleghorn Avenue, Nashville, Tn 37215
USA

For sales and distribution in Australia
EDUCATIONAL SUPPLIES PTY LTD
8 Cross Street, Brookvale, NSW 2100
Australia

NOTES